IMAGES
of America

IRISH
PHILADELPHIA

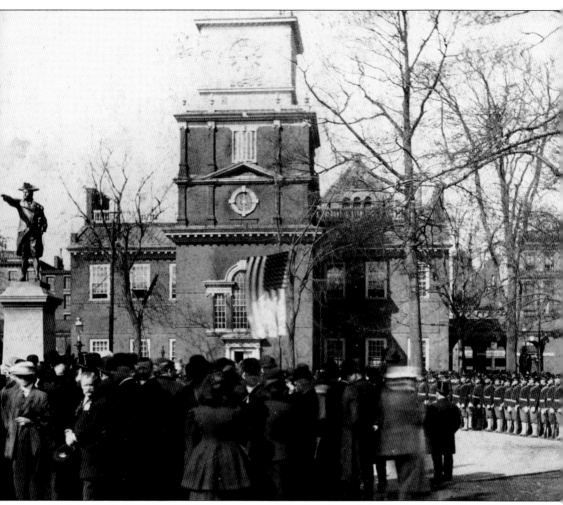

On March 16, 1907, the 136th anniversary of the founding of the Society of the Friendly Sons of St. Patrick, the society dedicated a statue of Commodore John Barry (1745–1803), the father of the US Navy and an Irish hero of the Revolutionary War. Philadelphia sculptor Samuel Murray (1869–1941) designed the bronze monument. It stands in Independence Hall Square and rises nine feet, six inches in height on a 12-foot-high Barre granite pedestal. Around 15,000 spectators attended the dedication. (Philadelphia Archdiocesan Historical Research Center.)

ON THE COVER: The Irish in Philadelphia first celebrated St. Patrick's Day in 1771, five years before the Declaration of Independence, and have had over 240 continuous years of celebration. The St. Patrick's Day Observance Association incorporated as a nonprofit organization in 1952 and hosted its eighth parade in 1959. Pictured, Judge Vincent A. Carroll, grand marshal, doffs his hat to a crowd of more than 100,000. Marchers behind Judge Carroll are, from left to right, Mayor Richardson Dilworth, city council president James Hugh Joseph Tate, and parade chaplain Msgr. Thomas J. Rilley. The Benjamin Franklin Parkway, built by Irishman "Sunny" Jim McNichol, had a green line painted down its center. (Robert and Teresa Halvey Photography Collection, Philadelphia Archdiocesan Historical Research Center.)

IMAGES
of America

IRISH
PHILADELPHIA

Marita Krivda Poxon
Foreword by Justice Seamus P. McCaffery

ARCADIA
PUBLISHING

Published by Arcadia Publishing
Charleston, South Carolina

Printed in the United States of America

Library of Congress Control Number: 2012941197

For all general information, please contact Arcadia Publishing:
Telephone 843-853-2070
Fax 843-853-0044
E-mail sales@arcadiapublishing.com
For customer service and orders:
Toll-Free 1-888-313-2665

Visit us on the Internet at www.arcadiapublishing.com

Local photographer Patricia Brown Negron took this head shot of Dr. Dennis Clark (1927–1993) for a photographic exhibition that honored the Irish—his lifetime study. Held at the Balch Institute in the summer of 1983, the exhibition, *Irish Eyes Still Smiling: Two Centuries in Philadelphia,* was sponsored by the Balch Institute for Ethnic Studies and the International House of Philadelphia. Clark's scholarship on the Irish in Philadelphia has been unsurpassed. (*Irish Edition.*)

CONTENTS

FOREWORD

Philadelphia, the Irish, the American dream, from quite an unlikely and improbable beginning, I reflect the confluence of those three things. After serving the city of Philadelphia for 20 years as a police officer and detective, my adopted city elected me to serve as one of its judges. After that, I was elected out of Philadelphia to the Supreme Court of Pennsylvania. What an embodiment of living the American Dream! I was born in Belfast, Northern Ireland, to a working-class family that ended up leaving the country they loved because of religious discrimination against Catholics. My parents brought us to America because of the myriad of marvelous opportunities this country provided that did not exist in Ireland. Yet, they instilled in us a love of the land of our birth by immersing us in the lively Irish culture that flourished in Philadelphia. Raised in Germantown, a thriving ethnic neighborhood in Philadelphia, we always gave the name of our Irish Catholic parish, Immaculate Conception, when asked where we lived. Like generations of Irish immigrants before and after us, our parents found comfort and familiarity in their newly adopted country in part by staying involved with the many Irish community organizations in Philadelphia. The Irish Center in Mount Airy was a hugely popular gathering point for Irish and the surrounding counties as well. There were many Ancient Order of the Hibernians clubs where the Irish met to socialize and to organize fundraisers for Irish Catholic causes. We children looked forward every year to cheering as the many different aspects of Irish life and culture were represented by the thousands who marched in the Philadelphia St. Patrick's Day Parade to show their pride both in their homeland and in America. We were anchored to our cultural traditions by these events and gathering places.

The Irish in Philadelphia needed these kinds of affiliations and support because early Irish immigrants in Philadelphia often encountered hostility and discrimination. At its worst, several Irish Catholic churches were burned to the ground, and Irish immigrants were often relegated to working as unskilled laborers. As the Irish community grew in size and influence, things began to improve. While I was still "hanging on corners" and growing up Irish in Philadelphia, Philadelphia was developing political machines in which the Irish became major players. In 1962, the city elected its first Irish Catholic mayor, James Tate. The Irish in Philadelphia had become powerful and influential. Forty-five years later, there was a great deal of Irish-Philadelphia pride that went into helping to elect one of Philadelphia's own to the highest court in the Commonwealth of Pennsylvania. I am so proud of my Irish heritage, and I love my adopted city. You are about to meet many Irish and learn more about Philadelphia. Enjoy the journey. Erin Go Bragh!

—Seamus Patrick McCaffery
Justice of the Supreme Court of Pennsylvania

ACKNOWLEDGMENTS

The author has had the great pleasure to meet many knowledgeable people during the course of the research and writing of this book. My deepest thanks go to Shawn Weldon, the skilled archivist at the Philadelphia Archdiocesan Historical Research Center (PAHRC) who introduced me to the center's collections and the photography of Robert S. Halvey. Individuals at the Commodore Barry Club shared with me their knowledge of the Irish along with some very rare photographs. They are Sean McMenamin, Billy Brennan, and Frank Hollingsworth. I worked with Tony Byrne and Jane Duffin, publishers of the *Irish Edition*, who allowed use of their extensive newspaper files. Through them, I met Tom Keenan, a professional photographer of local Irish events. He has allowed me to publish many of his photographs and masterfully scanned many others. Other sources for the book are: Seamus Boyle, the Ancient Order of the Hibernians (AOH); Rich Galassini, Cunningham Piano Company; Charles Barber and Harry McGee, Fireman's Hall Museum; Aurora Deshauteurs, Free Library of Philadelphia; Tom Showler and Russell W. Wylie, Society of the Friendly Sons of St. Patrick; Elizabeth Fite, the Hagley Museum and Library; Hillary Kativa, the Historical Society of Pennsylvania; Jim Coyne, John Donovan, and Kathy McGee Burns, the Irish Memorial, Inc.; Nicole Joniec, the Library Company of Philadelphia; Matt Regan, MacSwiney Club; Sr. Polly McShain, Betsy McShain Bracken, and Jim Bracken, the McShain family; Maureen O'Rourke Boccella; Jackie Rose, *Philadelphia Inquirer*; Aaron Neuman, Philadelphia Photographics; Robert Cheetham, PhillyHistory/Azavea; Delories Richardi, Rosemont College Archives; Eileen E. Troxell, St. Malachy Catholic Church; Carole Smith, Scotch-Irish Society; Robert Morris Skaler; Brenda Galloway-Wright and Carol Ann Harris, Temple University Urban Archives; Thomas Trainer Sr.; and Michael Foight, Villanova University Special Collections.

My husband, T. Michael Poxon, deserves praise for his constant support. I owe my inspiration to Dennis Clark, a writer I never had the fortune to meet. His research on the Irish has been unsurpassed. Lastly, I thank my late mother, Margaret Mary Finnegan Krivda, who encouraged me to pursue my postgraduate education in Ireland at Trinity College Dublin.

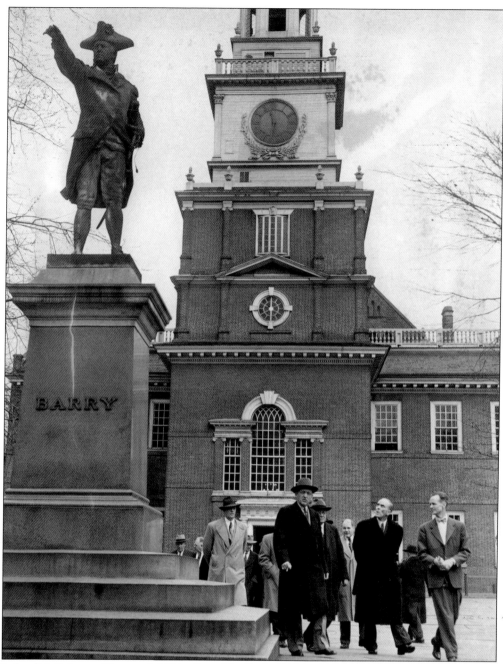

Ireland's Minister of External Affairs Seán MacBride (1904–1988) looked up at the Commodore John Barry Memorial on a visit to Independence Hall Square on March 16, 1951. Prominent Irishmen Judge Vincent A. Carroll and Dr. Edward Riley, chief park historian, were his escorts. MacBride was the son of famed actress Maude Gonne and John MacBride, both Irish nationalists. He earned fame as a United Nations commissioner, a founding member of Amnesty International, and the author of the MacBride Principles. In 1991, Congress by Public Law 102-92 proclaimed September 13 "Barry Day," the date in 1803 when Commodore John Barry died. (Temple University Urban Archives.)

INTRODUCTION

John Fitzgerald Kennedy in his address given on St. Patrick's Day on March 16, 1957, at the 186th annual banquet of the Society of the Friendly Sons of St. Patrick declared:

> "All of Irish descent are bound together by ties that come from a common experience . . . the special contribution of the Irish, I believe, the emerald thread that runs throughout the tapestry of their past, has been the constancy, the endurance, the faith that they displayed through endless centuries of foreign oppression and their mass destruction by poverty, disease, and starvation."

The Philadelphia Irish have a distinguished presence that extends back before the American Revolution. But their arrival in large numbers after 1844 triggered Nativists to riot against them. These famine Irish, at first huddled in slums, brought their Catholic faith with them, which sustained them. Fortunately, their arrival coincided with the industrial awakening of Philadelphia. These mainly rural refugees adjusted to city life. The sons of the famine immigrants became machinists, loom fixers, stevedores, locomotive mechanics, and skilled tradesmen. The daughters of these famine immigrants worked in mills, garment factories, nursing wards, and domestic service. During the 19th century, many Irish achieved middle-class status and some even acquired wealth. This group contributed to the building of Catholic churches, schools, hospitals, and other institutions, which allowed many of the Irish to rise economically, professionally, and politically. Philadelphia-based Irish Catholic philanthropies helped to establish Catholic institutions of higher education, including Villanova College (1842), St. Joseph's College (1851), and LaSalle College (1868).

The Irish managed to sustain their identities with strong family groups with recognizable Irish surnames like Kennedy, Kelly, Fitzpatrick, and endless others. Their Catholic faith bound them together in parishes where the Irish knew one another in their childhood parochial school playgrounds, in their parish hall dances and sports teams, and finally in their adult clubs. Associations went beyond the family and created broader-based societies with larger memberships. Since its founding in 1771, the prestigious Society of the Friendly Sons of St. Patrick organized the colonial Irish and had exceptional leadership starting with the society's first president, Stephen Moylan, Washington's quartermaster general. Men like Thomas McKean and Thomas Fitzsimons, signers of the Declaration of Independence, forged an Irish identity of bravery, intelligence, and loyalty to their new country's democratic ideals. In the 19th century, the Philadelphia Irish formed associations to support various nationalistic groups in Ireland itself, including the Fenian Brotherhood and the Clan na Gael. Mutual aid groups were founded to support Ireland's 32 counties—Mayo and Donegal being the first organized. The Total Abstinence Brotherhood promoted sobriety and Catholic morality. Large groups, such as the Irish Catholic Benevolent

Union, the Ancient Order of the Hibernians, the Irish Land League, and others, had local chapters that assembled in their own halls. Early in the 20th century, the Irish American Club and today the Irish Center, known also as the Commodore Barry Club, have witnessed hundreds of gatherings that have raised money for a myriad of Irish benevolent causes.

The Philadelphia Irish established a strong tradition of communication through powerful orators, public recitations, Irish newspapers, and, in the 20th century, Irish radio broadcasting. In 1860, 17 of Philadelphia's 24 wards had Irish-born populations of between 10 percent and 28 percent. The Irish-born population in Philadelphia seldom fell below 100,000 people. Since the 1800s, there have been 18 Irish papers for this large group. The archdiocesan weekly paper, the *Catholic Standard & Times*, was founded in 1866 and featured steady coverage of Irish news along with religious news. Since 1981, the *Irish Edition* has been a vehicle for Irish news about local cultural events as well as news directly from Ireland. Patrick Stanton's *Irish Hour* on the radio for 50 years brought Irish news and music since its first broadcast on March 17, 1926, until 1976. Stanton acquired his own radio station, WJMJ, which broadcasted Irish music, and his *Irish Hour* gave airtime for short lectures and addresses on Irish topics. Skillful use of the media helped to link the Philadelphia Irish community together.

Local Irish leadership in religion, Irish nationalism, and politics has always been powerful. It has had many faces from radical priest leaders, like Fr. Patrick Moriarity in the 1860s, to the solidly conservative, like Cardinal Dennis Dougherty. Michael J. Ryan in the 1890s rallied for peaceful constitutional change in Ireland while Joseph McGarrity plotted military insurrection, going so far as to purchase the guns for the 1916 Easter Uprising. Some families became leaders in business and created fabled wealth passed from generation to generation. The Kelly family, the McIlhenny family, the McShain family, the Trainer family, and others created fortunes that were used to enrich the Irish community in Philadelphia.

The Irish in Philadelphia throughout the centuries kept their family identities, formed strong associations for social support and promotion, opened up powerful channels to communicate with one another, and fostered the growth of strong leadership. The emerald thread formed in part by their great faith and in part by their sheer grit—both has been woven into the tapestry of Philadelphia's history for over 300 years. May "the wearin' of the green" continue to honor great and glorious St. Patrick from the Emerald Isle every 17th of March.

—Marita Krivda Poxon
Philadelphia, 2012

One

THE COLONIAL IRISH

Twenty-eight notable men of Irish birth or lineage risked their lives and fortunes for America in the Revolutionary War. The United Irish Societies of Philadelphia unveiled a bronze tablet to commemorate these heroes. The tablet, placed at the south entrance to Philadelphia's city hall, was unveiled on Saturday, December 4, 1926. The Honorable Michael J. Ryan gave a stirring keynote address. Among the heroes reviewed was Philadelphia's Thomas McKean (1734–1817), born of Scots-Irish parents, who became the chief justice of Pennsylvania from 1777 to 1799. (PhillyHistory.org.)

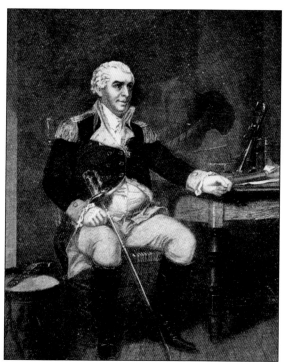

Born on March 25, 1745, in a thatched cottage in Tacumshane, County Wexford, Commodore John Barry had a passion for maritime life and at the age of 14 came to Philadelphia. Martin Ignatius Joseph Griffin (1842–1911) first published this Barry portrait, done in the style of Chappelle, in his 1902 biography, *The Story of John Barry: Father of the American Navy.* Barry was a commanding figure at six feet, four inches tall with a dignified carriage and handsome Irish features. (PAHRC)

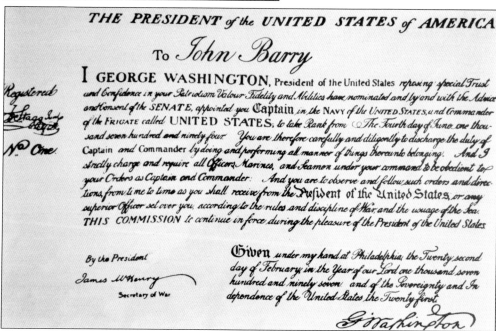

Under the new constitution, Congress authorized Pres. George Washington to confer upon John Barry Commission No. 1 as captain and commander of the US Navy. On the document, the commission was backdated to June 14, 1794. Washington actually signed it on February 22, 1797, on his own birthday. Barry served as senior officer of the US Navy with the title commodore under the command of three presidents: George Washington, John Adams, and Thomas Jefferson. (Irish Center.)

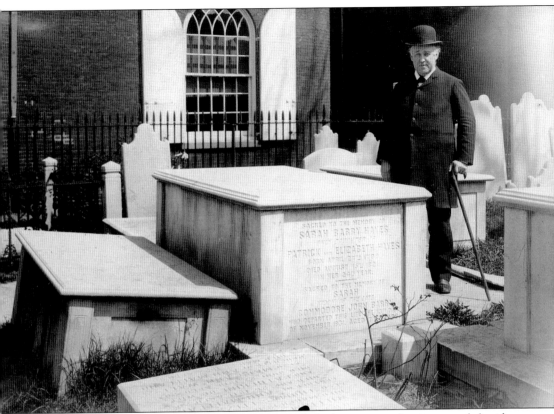

Here, Martin Ignatius Joseph Griffin (1842–1911), Catholic historian and writer, stands beside the tomb of Commodore John Barry in Old St. Mary's Cemetery. As a founder of the American Catholic Historical Society in 1884, he glorified the legacy of the Revolutionary War's Catholic heroes. Old St. Mary's was the parish church of Capt. Thomas Fitzsimons (1741–1811), Col. Stephen Moylan (1737–1811), and George Meade. This table tomb was the second for Barry and was erected in 1876 after the epitaph had become illegible. (PAHRC)

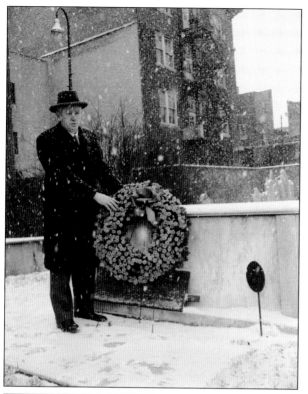

Prime Minister of Ireland John A. Costello (1891–1976) placed a wreath on Commodore John Barry's grave on March 18, 1956. A principal legal advisor to the government of the Irish Free State, Costello had given an address the night before at the annual Friendly Sons of St. Patrick dinner. He led the Fifth Government of Ireland from 1948 to 1951 and the Seventh Government from 1954 to 1957. He was a member of Fine Gael party, the rival party of de Valera's Fiana Fail. (PAHRC)

During the 1950s, the city of Philadelphia held Barry Day Parades in September. In the 1957 parade, 6,000 marchers represented the armed forces, fraternal groups, and Irish organizations. Wearing kilts, the band of the Donegal Society marched the parade route along the Parkway down Chestnut Street to Independence Hall. (PAHRC, Halvey)

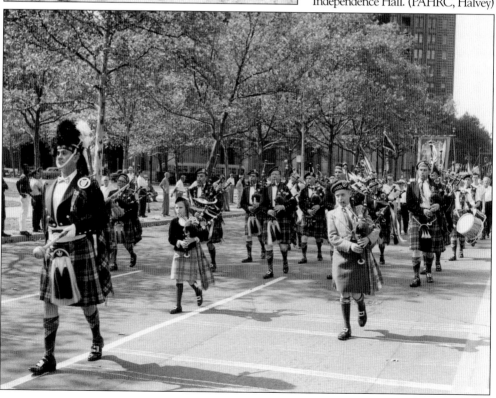

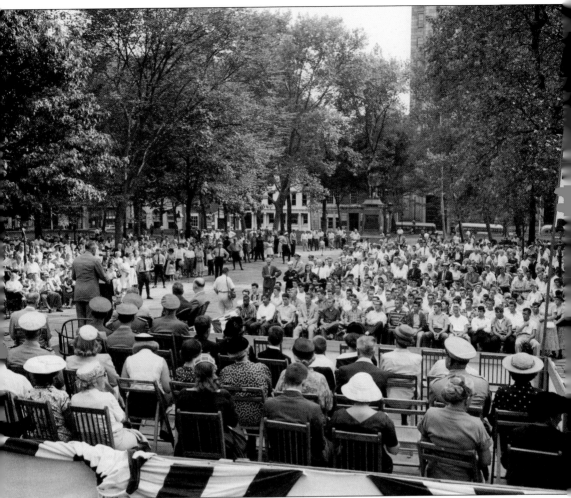

Richardson Dilworth (1898–1974), a Democratic mayor in Philadelphia from 1956 to 1962, spoke after the Barry Day Parade at Independence Square Park. The John Barry monument faced him. J. Sinclair Armstrong, the assistant secretary of the Navy, gave the principal speech. He then swore in 85 new Navy recruits. (PAHRC, Halvey)

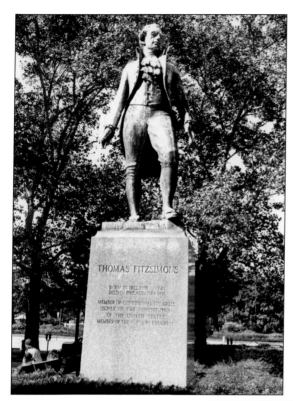

Thomas Fitzsimons (1741–1811), born in Ballikilty, County Wexford, worked as a clerk in a mercantile house. Fitzsimons became active in the Philadelphia Irish community and the Society of the Friendly Sons of St. Patrick. He was delegate to the Continental Congress in 1782 and 1783. He was one of only two Catholic signers of the US Constitution, the other being Daniel Carroll of Maryland. Although interred close to the graves of John Barry and George Meade in Old St. Mary's Cemetery, Fitzsimons was the largest contributor to St. Augustine Church. (PAHRC, Halvey)

The statute of Thomas Fitzsimons, located on Logan Square at Eighteenth Street, was first unveiled on September 17, 1946, the 159th anniversary of the Constitution. The Friendly Sons of St. Patrick commissioned Giuseppe Donato to cast this life-size bronze figure. In this 1957 photograph, members of the Friendly Sons placed a wreath at the site. In the foreground are John W. Laird (left) and Pres. F. Raymond Heuges, and in the background are historians Owen B. Hunt (left) and John J. Reilly. (PAHRC, Halvey)

Old St. Joseph's Church started out as a colonial home, the residence of English Jesuit Rev. Joseph Greaton, in 1733. In 1734, as a result of the religious freedom granted by William Penn's Charter of Privileges, Reverend Greaton openly celebrated Philadelphia's first public Mass in a small chapel. Over 800 Philadelphia Catholics, many church members with Irish heritage, served in the Revolutionary army and navy. Old St. Joseph's second pastor, Rev. Felix J. Barbelin, SJ, (1808–1869) built the current brick church in 1839. It was designed by Irish master builder John Darragh. (PAHRC)

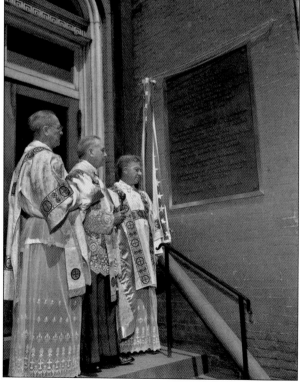

A bronze plaque outside Old St. Joseph's Church commemorated William Penn's "Liberty of Worship" granted to all Pennsylvanians. The plaque was blessed in April 1956 after its installation. In 1992, the Old St. Joseph's Historic Preservation Corporation was formed to promote public understanding of the significance of Old St. Joseph's in shaping America's religious, intellectual, and cultural history since its founding in 1733. The corporation in particular promotes the history of the Jesuit Order and maintains extensive archives. It preserves the physical structures—the 1839 church and 1787 clergy house. (PAHRC, Halvey)

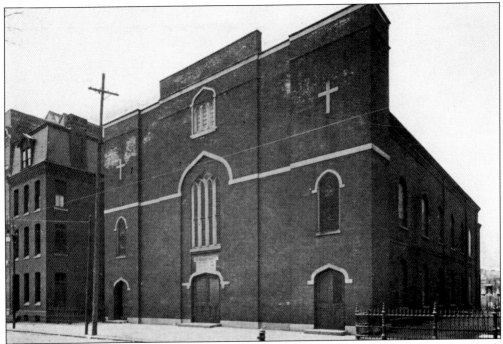

Founded in 1763 on South Fourth Street, Old St. Mary's Church, the second Catholic church in Philadelphia, was the site of the first public religious commemoration of the Declaration of Independence on July 4, 1779. At the close of the Revolution on November 4, 1781, George Washington along with members of the Continental and French armies prayed together at a solemn Mass of Thanksgiving. Under Irish-born Bishop Michael Egan (1761–1814), the church became the first Roman Catholic cathedral of the Diocese of Philadelphia from 1810 to 1838.(PAHRC)

Son of an Irish immigrant, Rev. Michael Hurley, OSA, (1778–1837) was born in Philadelphia. He became an Augustinian priest. In 1807, he served as secretary of the Board of Trustees of St. Mary's Church as well as a priest at Old St. Joseph's. He was the chaplain of the Hibernian Society from 1809 to 1813, active in the founding of St. Joseph's Orphan Asylum and St. Augustine Academy (1811) on Fourth Street, a forerunner of Villanova University. (PAHRC)

John Nixon (1733–1808), born in Philadelphia, was the son of Richard Nixon from County Wexford, Ireland, a prominent shipping merchant. Nixon inherited his father's business in 1749. In 1776, he was appointed to the Continental Navy Board. Nixon was selected to give the first public reading of the Declaration of Independence at the State House in Philadelphia on July 8, 1776. He was a founding member of the Friendly Sons of St. Patrick. (Krivda.)

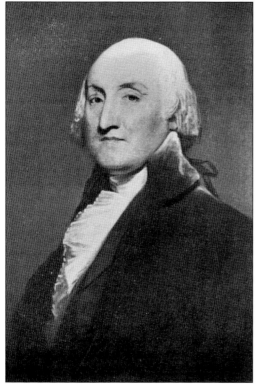

John Barclay (1749–1824), born in Ballyshannon, County Donegal, enlisted in the Continental army in 1775. He rose to lieutenant in October 1776 and retired as a captain in 1781. He came to Philadelphia in 1790 to participate in the Constitutional Convention as the last lay president justice of the Bucks County Courts. In 1792, he was one of the founders of the Insurance Company of North America and served as a director until 1793. He was a member of the Friendly Sons of St. Patrick. (Krivda.)

David Hayfield Conyngham (1750–1834), a graduate of Trinity College Dublin, was the son an Irish Quaker from Letterkenny. The family began the prominent local shipping company, Conyngham & Nesbit, active from 1745–1802. He joined the first militia company formed in Philadelphia and the First City Cavalry Troop in 1777. He settled in Woodford Mansion in 1783 and then built Clermont Mansion in Germantown. He was a founding member of the Friendly Sons of St. Patrick. (Krivda.)

Mathew Carey (1760–1839), born in Dublin, printed the first American version of the Douay-Rheims Bible, the first Roman Catholic Bible. While in Ireland, he wrote a pamphlet critical of the Penal Code against Roman Catholics. Fearful of imprisonment, he fled from Ireland and emigrated to Philadelphia in 1784. The Marquis de Lafayette gave him $400 to open his publishing business. Carey was a founder and the first secretary of the Hibernian Society for the Relief of Emigrants from Ireland. (Krivda.)

Two

THE FAMINE GENERATION

Michael Francis Egan, OFM, (1761–1814) was born in Limerick where he joined the Franciscans. He worked at the Franciscan St. Isidores College in Rome from 1787 until 1790. In April 1803 until his death, he was a pastor of Old St. Mary's. In 1808, Archbishop John Carroll of Baltimore recommended his appointment as bishop of the new Diocese of Philadelphia. Many Philadelphia bishops have been Irish born, including his successors Henry Conwell (1747–1842), born in Moneymore, Derry, and Francis Patrick Kenrick, born in Dublin. (PAHRC)

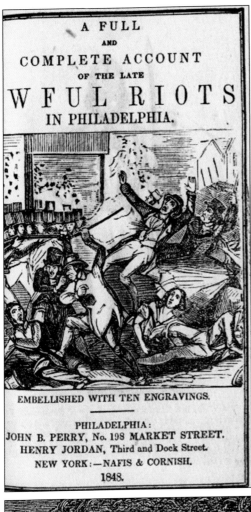

A FULL
AND
COMPLETE ACCOUNT
OF THE LATE
WFUL RIOTS
IN PHILADELPHIA.

EMBELLISHED WITH TEN ENGRAVINGS.

PHILADELPHIA:
JOHN B. PERRY, No. 198 MARKET STREET.
HENRY JORDAN, Third and Dock Street.
NEW YORK:—NAFIS & CORNISH.
1848.

John B. Perry wrote *A Full and Complete Account of the Late Awful Riots in Philadelphia: Embellished with Ten Engravings* (1844). It narrated a vivid account of the Nativist party's anti-Catholic riots. From May 3 through May 6, 1844, the Nativists held rallies in the predominantly Irish neighborhood of Kensington. When Lewis C. Levin (1808–1860) began to speak on the issue of popery, violence erupted. Nativists roamed around Kensington attacking the houses of Irish Catholics.(PAHRC)

On Wednesday, May 8, 1844, the rioting continued with yet more houses destroyed. Some residents in an effort to save their homes began hanging American flags in their windows, or writing Native American on their door in charcoal. The Nativists had the support of the Protestant press with even the summoned local militia siding with the Nativists. Many priests had to flee the city, and Bishop Francis Patrick Kenrick took refuge with an Episcopalian minister. (PAHRC)

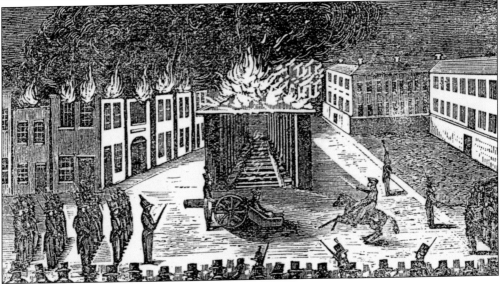

Fr. Terrence J. Donaghoe (1795–1869), born in Aughnacloy, Tyrone, was appointed by Bishop Francis Patrick Kenrick in 1833 as pastor of St. Michael Church. Built at Second Street above Master Street in the Gothic style by architect William R. Crisp, St. Michael became the target of the protestant Nativists party. The church, its rectory, and the Sisters of Charity's convent were all burned to the ground on May 8, 1844. Father Donaghoe witnessed the burning of the church from the cupola of St. Augustine Church. Sheriff Morton McMichael had no power to raise an armed force to stop the rioters. (PAHRC)

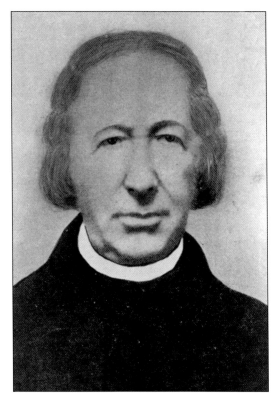

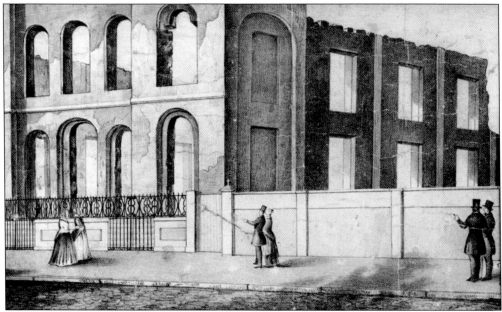

On the evening of May 8, 1844, a young Nativist boy set fire and destroyed St. Augustine Catholic Church. The fire also destroyed a fine library. St. Augustine, built in 1801 and located at 243 North Lawrence Street, had a theological library, which contained over 3,000 volumes. During the cholera epidemic of 1832, Pastor Michael Hurley, OSA, (1780–1837) opened the church doors to all denominations. The Augustinian Order arrived in the United States in 1796. (PAHRC)

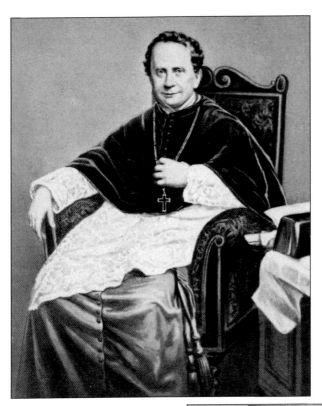

Francis Patrick Kenrick (1796–1863) was born in Dublin, educated at the Urban College in Rome, and served as the third bishop of Philadelphia from 1842 to 1851. His tenure was marked by the 1844 Philadelphia Nativist Riots. After the destruction of St. Michael and St. Augustine Churches, he closed all Catholic churches on May 10, 1844, until the riots were brought to a halt by military force. After the riots, Bishop Kenrick ceased with his efforts to influence public schools and worked tirelessly to establish a Catholic parochial school system. (PAHRC)

Bishop Francis Patrick Kenrick published this broadside on May 7, 1844, and placed it throughout Kensington, advising Catholics to stay indoors. Throughout the violence, Kenrick encouraged Catholics "to follow peace" and have charity. (PAHRC)

TO THE
CATHOLICS
OF THE
CITY & COUNTY
OF PHILADELPHIA.

The Melancholy Riot of Yesterday, which resulted in the Death of several of our fellow beings, calls for our deep sorrow. It becomes all who have had any share in this Tragical Scene to humble themselves before God, and to sympathize deeply and sincerely with those whose relatives and friends have fallen. I earnestly conjure all to avoid all occasion of excitement, and to shun public places of assemblage, and to do nothing that in any way can exasperate. Follow peace with all Men, and CHARITY, without which no man can see God.

+ FRANCIS PATRICK,
Bp. Phil.

Philadelphia, May 7th, 1844.

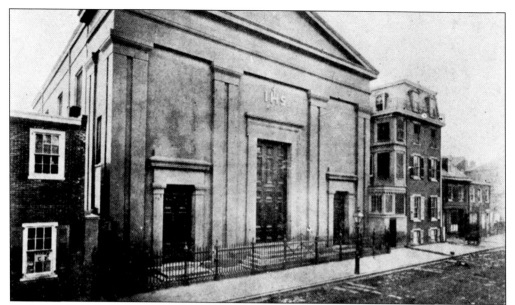

On July 2, 1844, Pastor J. Patrick Dunn (1809–1869) of St. Philip Neri Church in Southwark was warned of an imminent attack on his church. With permission from Gov. David Rittenhouse Porter (1790–1879) and Gen. Robert Patterson of the Pennsylvania militia, the pastor secured arms to protect the church. Governor Porter authorized the formation of a company, the Hibernia Greens. On July 4, 1844, the Nativists mob attempted to batter the church with a cannon but did not succeed in destroying the church. (PAHRC)

The Hibernia Hose No. 33 was an all-volunteer fire company entirely made up of Irishmen. Started November 22, 1842, the firehouse was located on Master Street, the epicenter of Irish Kensington where the 1844 riots began. The fire company stopped operation in January 1855 after the City of Philadelphia extended its boundaries to Kensington in 1854. Prior to this, neighborhoods like Kensington had to organize their own fire brigades along ethnic and political lines. (PAHRC)

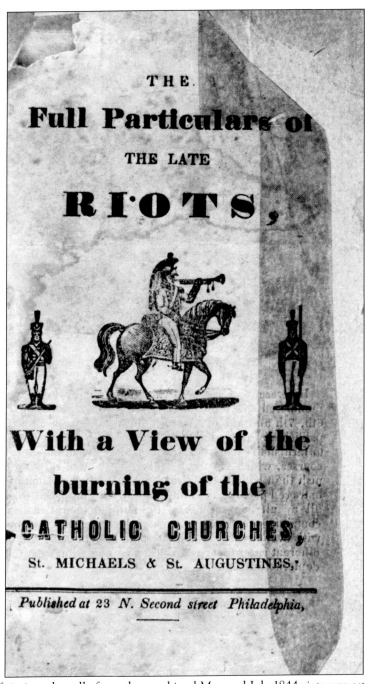

THE
Full Particulars of
THE LATE
RIOTS,
With a View of the
burning of the
CATHOLIC CHURCHES,
St. MICHAELS & St. AUGUSTINES,

Published at 23 N. Second street Philadelphia,

After days of rioting, the tally from the combined May and July 1844 riots was estimated at 20 dead and over 100 injured. Noted historian Dennis Clark has seen the riots as an intra-Irish phenomenon with militant Irish Protestants from the Nativist party fighting their local Irish Catholic neighbors. The following from an editorial in the *Pennsylvanian* caught the outrage of the city now under heavy guard: "Such is a Sunday in the 19th century in the city of Philadelphia. Religious toleration enforced by loaded muskets, drawn sabers, and at the cannon's mouth–charity secured through dread of grape and canister." (PAHRC)

Patrick Eugene Moriarty, born in Dublin in 1805, was a member of the Order of St. Augustine in 1822 at Callan, County Kilkenny. He became pastor of St. Augustine Church in 1839. Along with Fr. Thomas Kyle, he purchased an estate—Belle Air—in Radnor as a boys' academy, which they called the Augustinian College of Villanova, the forerunner of Villanova University. (PAHRC)

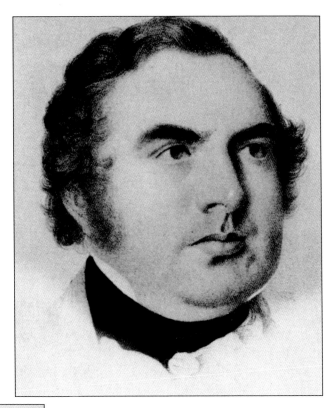

AN ORATION:

"What Right has England to Rule in Ireland,"

To the Quar. Cath. Hist. Society
from Fr. Thomas C. Middleton, O.S.A.
DELIVERED BY THE
Villanova College, Pa.
Hum, Pentecost Thursday,
May 22, 1902.

VERY REV. DR. MORIARTY,

IN THE

ACADEMY OF MUSIC,

MAY 23, 1864,

FOR THE FATHER LAVELLE FUND.

PHILADELPHIA:
JAMES GIBBONS, PUBLISHER, 333 CHESTNUT STREET.

1864.

At the Academy of Music on May 23, 1864, Dr. Moriarty gave a stirring speech to thousands of assembled Hibernians and Fenians. He argued that the English had no right to be in Ireland and that their intention was to exterminate the Irish people. The controversial speech benefited Fr. Patrick Lavelle of Partry who founded the St. Patrick's Brotherhood, a secret society identified with the Fenian Brotherhood and dedicated to driving the English out of Ireland. (PAHRC)

27

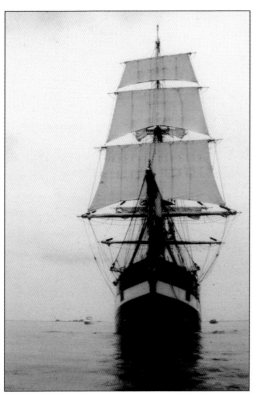

Built for the 150th anniversary of the Great Irish Famine, this replica of the *Jeanie Johnston* tall ship visited Philadelphia in June 2003. By 1845, Philadelphia had received Irish immigration for six generations. The seventh generation, the famine generation, came from Ireland in coffin ships to escape mass starvation. *Jeanie Johnston* (1847–1858), constructed in Canada, was a triple-masted 700-ton cargo ship purchased by John Donovan of Tralee, County Kerry. On its 16 voyages, it carried over 2,500 Irish emigrants with no loss of life. (Keenan.)

In 1845, a disaster struck rural Ireland when a fungus, phythophthora infestans, attacked the potato crop, Ireland's principal food. The years 1845 to 1850 have been called the Great Irish Famine when one million people died from starvation and disease. An additional two million emigrated to the United States, Canada, and Britain. The Irish arrived in Philadelphia from New York, supplementing the smaller direct emigration on the three ships a month that left Derry and regular ships from Liverpool. They crowded neighborhoods like Southwark, Schuylkill, Moyamensing, Kensington, and Port Richmond. (Krivda.)

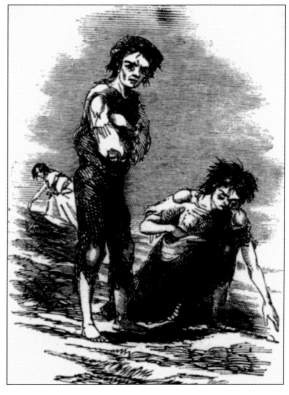

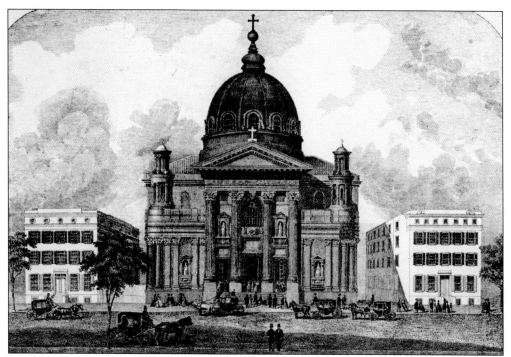

In 1832, Bishop Kenrick established the first diocesan seminary, St. Charles Borromeo, in his residences at St. Mary's Church. In 1838, he purchased a building for the seminary at what is now Eighteenth and Race Streets as well as adjacent land for a diocesan cathedral. The Philadelphia architect Napoleon LeBrun drew the original cathedral plan for the Cathedral Basilica of SS. Peter and Paul. The cornerstone was laid on September 6, 1846, a gift of James McClarnan. (PAHRC)

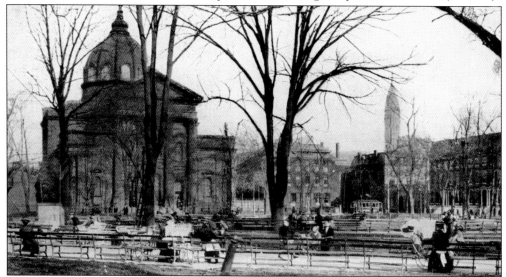

After Bishop Kenrick's departure, Bishop John Neumann and later Bishop James F. Wood worked to complete the cathedral finally finished in 1864. On November 20, 1864, Bishop Wood celebrated the Mass of dedication in the new cathedral. The cathedral was built with only very high clerestory windows 75 to 100 feet above street level to prevent vandalism. The fact that the cathedral was designed with no windows at street level was a reminder of the Nativists' riots. (Skaler.)

Fr. Eugene V. McIlhone, born in County Tyrone, founded St. Joseph's House for Homeless Boys in 1888 at 732 Pine Street under the patronage of Old St. Joseph's Church. Irish Catholic lay groups provided the funds for large institutions to improve the situation of orphans. The name changed at that time to St. Joseph's House for Homeless Industrious Boys. Two businessmen, Joseph F. McCarthy and John A. McCarthy, funded the new building. St. Joseph's House for Homeless Industrious Boys relocated to 1515 West Allegheny Avenue. (PAHRC)

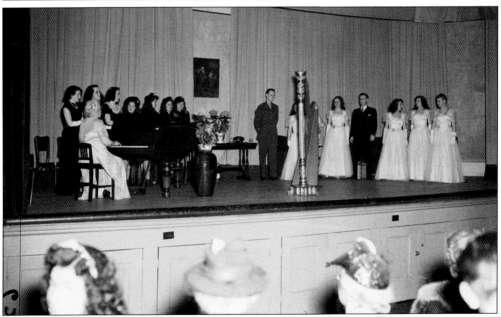

On April 27, 1946, Hubert Valentine, a celebrated tenor from Dublin, gave an Easter week Irish concert at St. Joseph's Auditorium. Local talent included harpist Mary Bryne, along with an ensemble of singers from nearby Little Flower Catholic High School, a parochial all-girls school at Tenth and Lycoming Streets. In addition, Francis Biggar, assistant Irish consul from New York, gave an opening address. (PAHRC, Halvey)

Three

NOTABLE IRISH AND THE CITY'S GROWTH

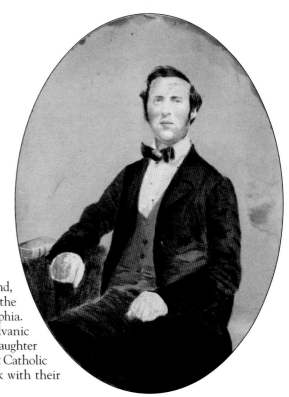

Patrick Coad (1783–1872), born in Ireland, became a noted teacher and lecturer on the natural sciences and medicine in Philadelphia. Coad invented and patented the first galvanic battery in March 1842. He married the daughter of Mathias James O'Conway, a prominent Catholic lexicographer. They lived in Southwark with their seven children. (PAHRC)

St. Clair Augustine Mulholland (1839–1910), born in Lisburn, County Antrim, settled in Philadelphia. During the Civil War, Mulholland was commissioned as lieutenant colonel of the 116th Pennsylvania Infantry, which was attached to Thomas Francis Meagher's Irish Brigade. He fought in many battles, including Chancellorsville and Gettysburg. He was active in the Society of the Friendly Sons of St. Patrick and worked as chairman of the Barry Monument Committee in 1907. (Krivda.)

Reenactors of the Irish Brigade, the 69th Pennsylvania Irish Volunteers portray the regiment in authentic Civil War uniforms and raise funds for projects, such as the location of unmarked gravesites of men who fought with the regiment during the Civil War. The unit played a large role at the Battle of Gettysburg, helping repel both Brig. Gen. Ambrose Wright's charge on July 2 and Pickett's Charge on July 3, 1863. (Keenan.)

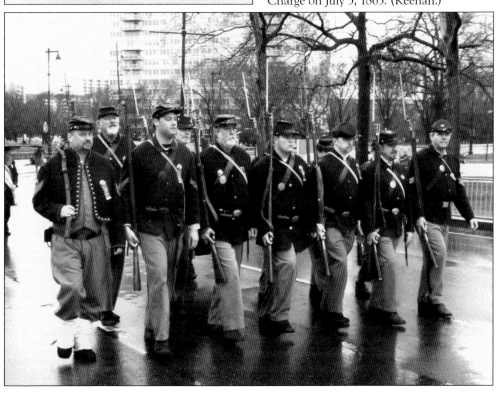

Joseph Tagert (1758–1849), born in County Tyrone, settled in Philadelphia in 1795. He owned his own importing firm Tagert & Smith. In addition, he was president of the Farmers & Mechanics Bank for 40 years. He was one of the city's first investment bankers. His strong ties to the Irish community included his work as president of the Society of the Friendly Sons of St. Patrick from 1818 to 1849. (Krivda.)

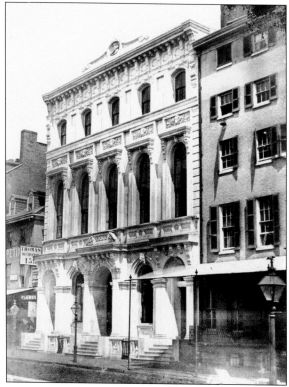

The Farmers & Mechanics Bank, incorporated in 1809, was the largest bank in the city during the latter part of the 19th century. Its headquarter building at 427 Chestnut Street was opened in 1855. John Myers Gries (1828–1862) designed the building, which incorporated an iron truss system over the main banking area. It had a white marble Italianate facade. (Library Company.)

Morton McMichael (1807–1879), born to Northern Irish parents, was a Philadelphia lawyer, editor, and politician. He began his career as editor of the *Saturday Evening Post* in 1826. He served a term as the first Irish mayor of Philadelphia from 1866 to 1869 and was president of the Fairmount Park Commission. McMichael helped to found the Union Club, now the Union League. He was active in the Society of the Friendly Sons of St. Patrick. A statue of McMichael stands at Sedgely and Lemon Hill Drives in East Fairmount Park. (Krivda.)

Robert Shelton MacKenzie (1809–1880) was born in Limerick and studied medicine at Trinity College Dublin. After 1830, he moved to London where he wrote for the *London Magazine* and later settled in New York City where he wrote for the *New York Times*. After 1855, he spent the remainder of his life in Philadelphia where he became a literary editor. He wrote a book, *Bits of Blarney*, filled with character sketches and Irish wit. (Krivda.)

The William J. Campbell Bookstore, founded in 1850 in Philadelphia by bookseller John Campbell (1810–1874), specialized in publishing local history and legal books. In 1874, William J. Campbell took over the operation of the bookstore upon the death of his father. The founder, John Campbell, emigrated from Ireland in the 1830s and was a strong supporter of the labor movement and social reform. (PAHRC)

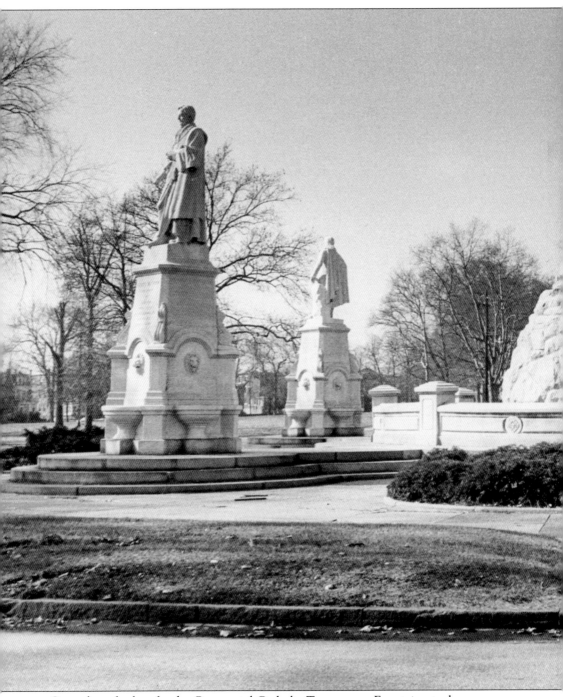

Ground was broken for the Centennial Catholic Temperance Fountain at a large ceremony on July 5, 1875, in West Fairmount Park near George's Hill. The national Centennial Committee of the Catholic Total Abstinence Union funded and built the fountain. The predominately Irish Catholic Total Abstinence group used the Temperance Fountain to demonstrate their patriotism, sobriety, and moral rectitude. The statuary commission went to Herman Kirn (Kern), a young Philadelphia sculptor. Costing approximately $50,000, the fountain was constructed entirely of

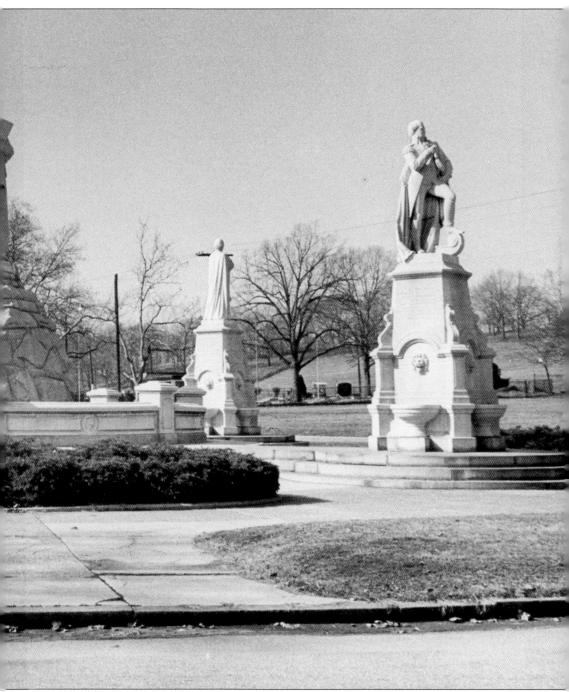

marble and granite. The fountain contains four life-size standing figures, all Irish or Catholic, which encircle the massive Biblical figure of Moses, the leader and lawgiver. The four figures are: John Carroll, the first commissioner of the Continental Congress; Charles Carroll, Irish Catholic signer of the Declaration of Independence; Commodore John Barry, the father of the American Navy; and Fr. Theobald Matthew, the Irish Apostle of Temperance. The platform, if viewed from above, takes the form of a Maltese cross. (PAHRC)

Martin Maloney (1847–1929), born in Ballingarry, Tipperary, moved to Philadelphia at the age of 26. Maloney obtained patents for improved gasoline burners used in street lighting. In 1876, he was awarded the contract to light the grounds of the Centennial Exposition. In 1880, he founded the Pennsylvania Globe Gas Light Company, which provided lighting for Philadelphia; he became a 19th-century oil-and-gas multimillionaire. He owned a portion of the Standard Oil Company and the United Gas & Improvement Company. For large donations to the Vatican, Pope Leo XIII named him a Papal Marquis in 1903. (PAHRC)

Martin Maloney built his summer residence, Ballingarry, at Spring Lake, New Jersey, which has been called the Irish Riviera. Designed by Horace Trumbauer, Ballingarry was a white mansion modeled after Dublin's town hall, which was James Hoban's prototype for the White House. The marble keystone was dug from the ruins of the Roman Coliseum. He often entertained the catholic hierarchy, including Philadelphia's Irish-born Archbishop Patrick John Ryan (1831–1911). (PAHRC)

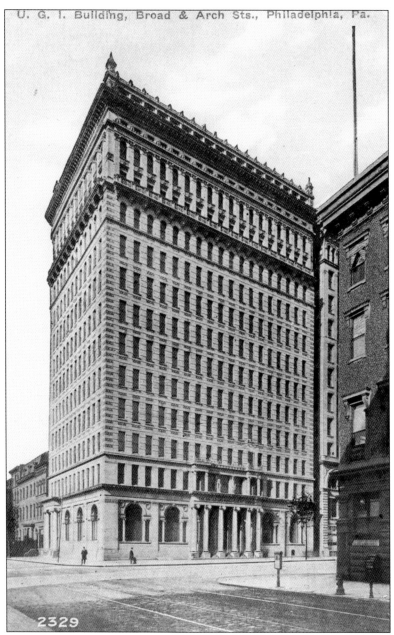

2329

The United Gas Improvement Company (UGI), located at the Corner of Broad and Arch Streets, was built in 1898. UGI's president was Irishman Thomas Dolan (1834–1914), one of Philadelphia's top financiers and industrialists, along with Irishman Martin Maloney. Dolan's fortune began with his first business, Keystone Knitting Mills, which made worsted goods during the Civil War. Later, he formed Thomas Dolan and Company whose mills covered three blocks on Mascher Street. Foreseeing electrical companies supplying street lighting, he lit up Chestnut Street for a year at no charge to induce the city to give him a contract. He got a city contract in 1897 to run the gas company after the city had run up deficits for 11 straight years. UGI controlled Philadelphia Electric Company and the Gas Works for a short time. Dolan, a director of the Union League from 1880 until 1883, served as its first vice president from 1884 until 1890. (Skaler.)

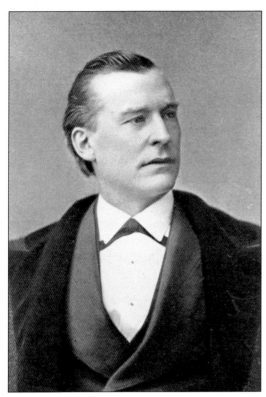

John McCullough (1832–1885), born in Blakes, County Derry, immigrated during the Great Irish Famine to Philadelphia. He taught himself how to read and joined a society of Irish tradesmen who staged amateur Shakespeare stage productions. McCullough acted in Philadelphia's Walnut Street Theater, where he was spotted by the great 19th-century actor Edwin Forest. Forest made him his protégé. He gave up the stage in 1884 due to an accident and lived in Kensington until his death. (Free Library of Philadelphia.)

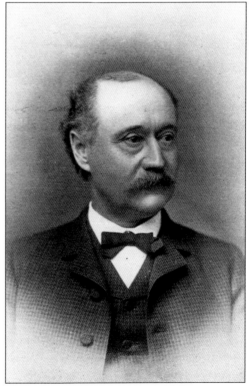

William Miskey Singerly (1832–1898), a third-generation Irish American from Northern Liberties and Kensington, quickly turned his inheritance of $750,000 in railroad stock into $1.5 million in real estate, expanding on his father Joseph's real estate holdings in just a couple of years. He acquired 28 acres between Broad and Twenty-second Streets, York and Dauphin, and built over 1,000 homes. In 1877, he branched out into publishing and turned the *Philadelphia Public Record*, a small paper, into a powerhouse for the Democratic party. (Krivda.)

Patrick J. Cunningham was an Irish immigrant who began manufacturing acoustic, upright, and grand pianos in 1891. Trained as an apprentice to a woodworker, he hired Irish and German skilled workers to build his pianos. Soon, he had a flagship store with satellite locations. In 1913, he purchased twin mansions at 1312 and 1314 Chestnut Street, which became his large showroom, offices, and warehouse. In 1922, he built another flagship store at 1322 Chestnut Street, which was higher than the John Wanamaker's Department Store. He manufactured his pianos in his factory at Fifty-seventh Street and Parkside Avenue in West Philadelphia. (Cunningham Piano Company.)

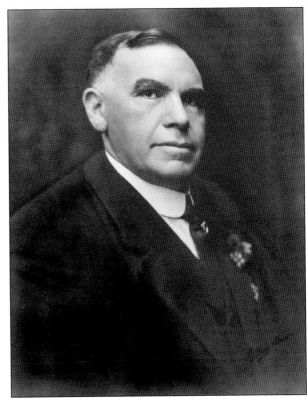

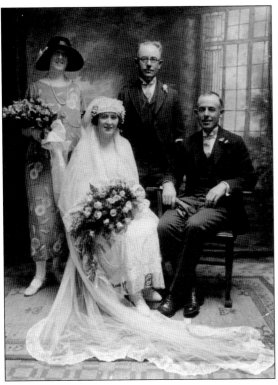

Helen R. O'Neill and John J. Duffin married at St. Anne Catholic Church in 1924 with the groom's brother David as best man and the bride's sister Marie as maid of honor. The two brothers worked as contractors, building churches for the Archdiocese of Philadelphia. Their father, David Duffin, a stonemason, started the business after he emigrated from Toomebridge, County Antrim, in 1889. Helen and John Duffin had seven children including Jane Duffin, the editor and cofounder of the *Irish Edition* newspaper. (*Irish Edition*.)

Eleanor Cecilia Donnelly (1838–1917) was a Catholic American poet and was known as "The Poet of the Pure Soul." Born in 1838 and educated at home by her mother, Catherine Gavin Donnelly, Eleanor began to write poetry at age nine. She published her first book in 1873, *Out of Sweet Solitude*, which addressed spiritual themes. Donnelly also served as the associate editor of the Philadelphia Catholic weekly paper, the *Catholic Standard & Times*. (PAHRC)

In 1914, Rose White posed with her husband, Thomas White, and their three children, from left to right, Alice, Thomas, and James. Eventually, she would have eight children. Thomas, a horse trainer in County Cavan, became a Philadelphia policeman. Rose was a fortunate young Irishwoman because she had attended Corlea National School in County Cavan from 1886 until 1894. In January 1968, her children published a booklet called *Memories from My School Books, 1886–1894*, which printed out the poetry that Rose had recited from memory. (O'Rourke.)

Four

IRELAND FOREVER

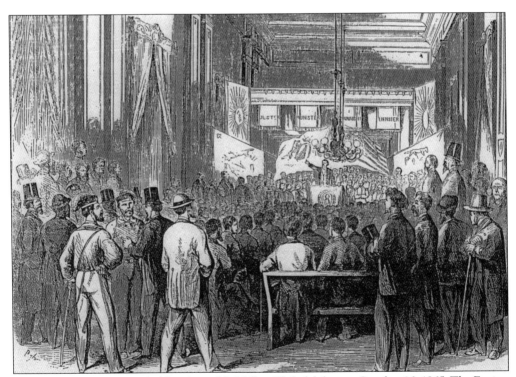

The Fenian Congress was held at Assembly Hall in Philadelphia on October 16, 1865. The Fenian Brotherhood was an Irish Republican organization founded in the United States in 1858 by John O'Mahony and Michael Doheny. Members were known as Fenians. It was a precursor to the Clan na Gael, a sister organization to the Irish Republican Brotherhood. The Fenian Brotherhood traced its origins back to the United Irishmen, an early secret revolutionary organization. (PAHRC)

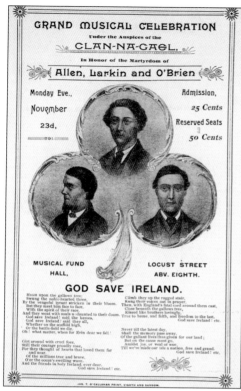

The Clan na Gael held a fundraiser on November 23, 1891, at the Musical Fund Hall on Locust Street above Eighth Street. On the printed program was a shamrock with photographs of the Manchester Martyrs: William Philip Allen, Michael Larkin and Michael O'Brien. They were publicly hanged for the murder of a Manchester policeman in 1867. All were members of the Irish Republican Brotherhood. (PAHRC)

The Clan na Gael Pipeband marched in the 1959 St. Patrick's Day Parade and posed for this photograph on the Benjamin Franklin Parkway. Clan na Gael is Gaelic for "family of the Irish." The Clan na Gael, an Irish political organization, had strong Philadelphia ties. Its major supporter was the wealthy Joseph McGarrity (1874–1940), who devoted much of his time and money to the cause of Irish independence. The Clan na Gael has been a supporter of Irish cultural events and festivals. (PAHRC)

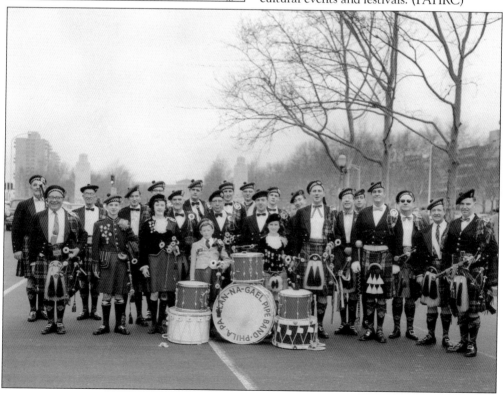

Joseph McGarrity (1874–1940), born in rural Carrickmore, County Tyron, settled in Philadelphia and soon joined the Clan na Gael. He grew wealthy distilling whiskey and selling real estate. He was the financier of the 1916 Easter Uprising in Dublin. He purchased and arranged delivery of 1,500 Mauser rifles and 49,000 rounds of ammunition used by the Irish volunteers. Éamon de Valera stayed in close contact. He opposed the Anglo-Irish Treaty of 1921, which facilitated the partition of Ireland. McGarrity donated his extensive library of historical books to Villanova University's Falvey Memorial Library. (Joseph McGarrity Collection, Digital Library at Villanova University.)

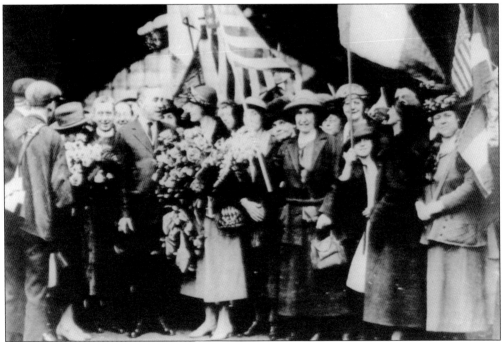

Joseph McGarrity greeted Countess Constance G. Markiewicz (1868–1927) at Broad Street Station in April 1922 on her American tour. The Countess and McGarrity fundamentally did not support the Peace Treaty and agreed that all 32 counties should be united in a single republic. On Easter Monday in 1916, clad in a green uniform and carrying a Mauser automatic pistol part of the McGarrity weapon shipment, Countess Markiewicz marched at the head of a small column of Citizen Army men to St. Stephen's Green. She was promptly arrested. Throughout her life, she was jailed for her political activism. (Joseph McGarrity Collection, Digital Library at Villanova University.)

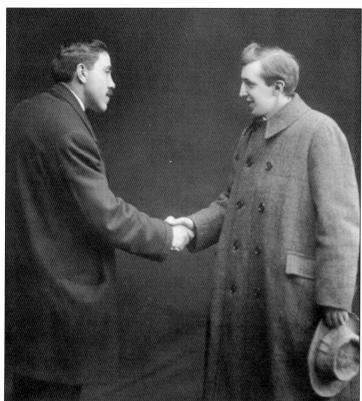

In 1900, John Bulmer Hobson (1883–1969) visited Joseph McGarrity (left) in Philadelphia to gain his support for the Irish Republican Brotherhood. Hobson was an early leading member of the Irish Republican Brotherhood and the editor of the radical publication *Irish Freedom*. Born in Belfast, he had a strict Quaker upbringing. In time, he lost power in the brotherhood because of his opposition to violence. He concentrated on writing Irish history later in his life. (Joseph McGarrity Collection, Digital Library at Villanova University.)

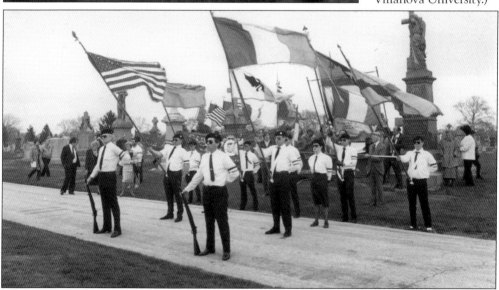

On April 17, 1983, the annual McGarrity commemoration took place at Holy Cross Cemetery in Yeadon where Joseph McGarrity is buried. At attention near McGarrity's monument, the honor guard unit of the local Irish Northern Aid Committee (Noraid) stood for the event. The ceremony honors McGarrity's pivotal role in the 1916 Easter Uprising in Dublin. The Irish Northern Aid Committee is an Irish American fundraising organization that started in 1969. It supports the establishment of a democratic 32-county Ireland. (*Irish Edition.*)

Luke Dillon (1850–1930), whose parents escaped from Sligo during the Great Irish Famine, came to live in Philadelphia where he befriended Joseph McGarrity and joined the Clan na Gael. He carried out bombings in England and Canada. He was known to the Irish revolutionary underground as "Dynamite Dillon." He was part of McGarrity's inner circle and assisted with the 1916 Easter Uprising. Like McGarrity, he is buried in Holy Cross Cemetery in Yeadon. (MacSwiney Club.)

Cathal Brugha, born in Dublin as Charles William St. John Burgess (1874–1922), joined the Irish Volunteers in 1913 as a lieutenant. His first prominent action as a volunteer was the Howth gun-running operation, funded by Joseph McGarrity. McGarrity and Brugha supported the third Irish Race Convention in Philadelphia from February 22 to February 23, 1919. With Brugha, McGarrity established an Irish Victory Fund through the Friends of Irish Freedom to garner international recognition of the Irish Republic. (Joseph McGarrity Collection, Digital Library at Villanova University.)

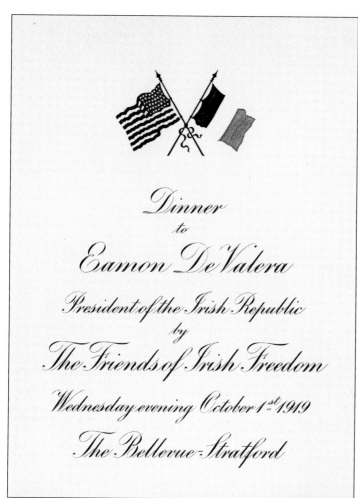

Dinner
to
Eamon De Valera
President of the Irish Republic
by
The Friends of Irish Freedom
Wednesday evening October 1st 1919
The Bellevue-Stratford

In 1919, sponsored by the Friends of Irish Freedom, Éamon de Valera began his two-month public speaking tour in Philadelphia where he was welcomed as an American hero. He was given an elaborate white-tie dinner at the Bellevue Stratford Hotel. Éamon de Valera (1882–1975) was born in New York City to an Irish mother and a Spanish Cuban father, Juan Vivion de Valera. He participated in the 1916 Easter Uprising. Even though sentenced to death, he was not executed because of his American citizenship. He authored the Constitution of Ireland in 1937 with John Hearne. He took a position unpopular with many. He championed the treaty, which divided Ireland. This compromise brought about the bloody Irish Civil War. (PAHRC)

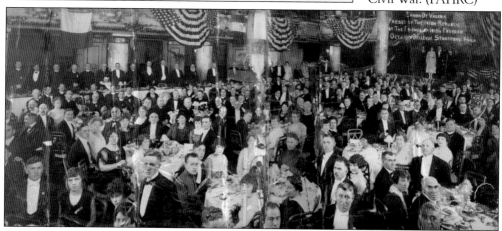

A rare surviving group photograph is seen here with those in attendance at the famous banquet on October 1, 1919, where Éamon de Valera spoke as president of the Irish Republic. The President de Valera Reception Committee included Michael J. Ryan (chairman), John P. Connelly, Msgr. Gerald P. Coghlan, Joseph McGarrity, and other prominent men. (MacSwiney Club.)

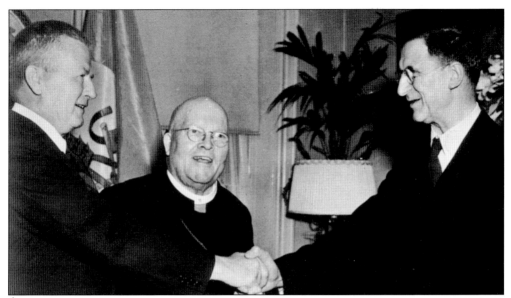

Éamon de Valera (right) returned to Philadelphia for another US fundraising tour on March 23, 1948, after an 18-year absence. The prime minister visited Cardinal Dennis Dougherty (1865–1951) at St. Patrick's Church Rectory. De Valera shook hands with Pennsylvania governor James H. Duff. A luncheon followed at the rectory at which Mayor Bernard Samuel extended the freedom of the city to de Valera. Later, de Valera placed a wreath on the tomb of Commodore John Barry. (PAHRC)

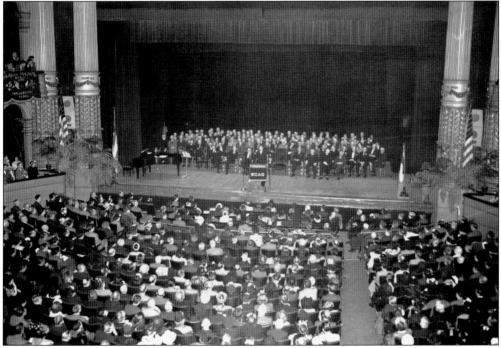

Éamon de Valera gave an address at the Academy of Music on Sunday, April 4, 1948, at 4:00 p.m. with over 3,000 people in attendance at the public meeting. He spoke on behalf of the American League for an Undivided Ireland. He appealed for British participation in a moderate settlement looking ahead to a unified Ireland. (PAHRC)

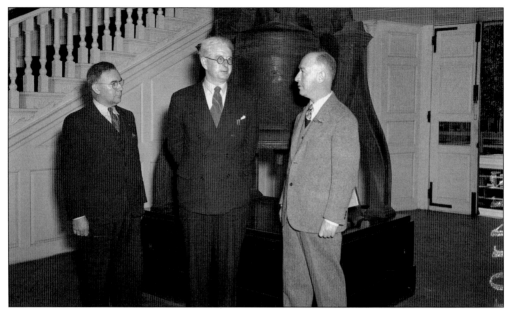

On May 31, 1947, Capt. Denis Ireland (center), Northern Irish member of Parliament, visited the Liberty Bell, which then was housed in Independence Hall. He was on a US tour sponsored by the Irish Anti-Partition League whose purpose was to remove the border in Ireland. The league, based in Northern Ireland, campaigned for a united Ireland. On Sunday, June 1, 1947, he spoke to a capacity crowd at a public meeting held in the Bellevue Stratford Hotel. (PAHRC)

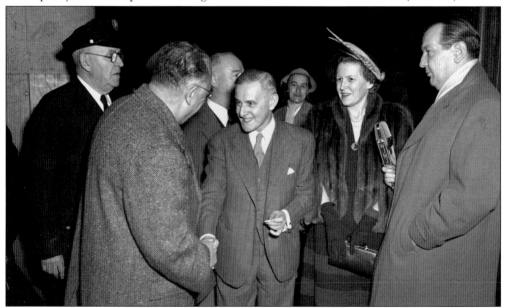

On March 29, 1950, while he was en route to Washington, DC, Hon. John Hearne (1893–1969), first Irish ambassador to the United States, stepped off the train at Thirtieth Street Station. With his back to the camera, Owen B. Hunt, historian of the Society of the Friendly Sons of St. Patrick, greeted him. Local broadcaster Patrick Stanton provided live commentary on his radio station WJMJ. Hearne assisted Éamon de Valera to draft a new constitution in 1937. For this work, he has been called "Ireland's Thomas Jefferson." (PAHRC, Halvey)

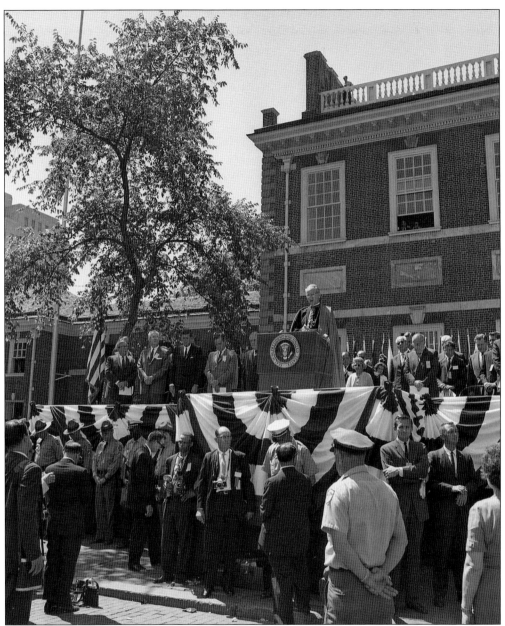

From a sun-drenched platform, Archbishop John J. Krol delivered the invocation prayer that opened the 1962 Fourth of July celebration in front of Independence Hall, Philadelphia. Later in the program, Pres. John Fitzgerald Kennedy from a distinguished Irish American family delivered a stirring speech to a crowd of more than 100,000 people. He called for global thinking and stressed the need for the United States to participate with the union of nations in a "mutually beneficial partnership" as a foundation for the "eventual union of all free men." The impressive lineup of Irish political giants on the platform includes, from left to right, Pennsylvania congressman William J. Green Jr., Philadelphia mayor James H.J. Tate (first Irish Catholic mayor), Pres. John Fitzgerald Kennedy, and Pennsylvania senator Joseph S. Clark Jr. (PAHRC, Halvey)

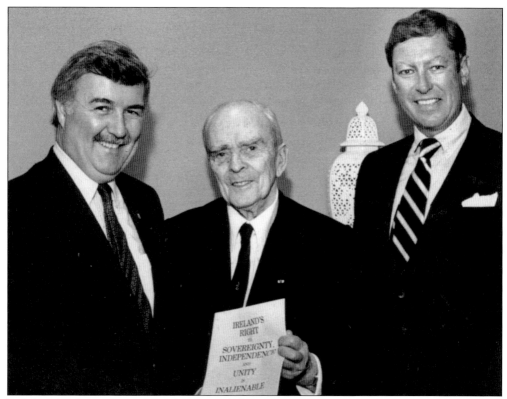

In July 1984, Seán MacBride, Irish 1974 Nobel Peace Prize winner, travelled to the United States for the 82nd National Hibernian Convention. He was flanked on the left by Joseph A. Roche, the National president of the Ancient Order of the Hibernians, and on the right by Frank Duggan, a legislative council representative. They planned to distribute a MacBride pamphlet to all US congressmen. The 11-page document was titled "Ireland's Right to Sovereignty, Independence, and Unity is Inalienable and Indefeasible." MacBride believed the document represented the Charter of Liberty of the Irish People. (*Irish Edition*.)

Seán MacBride (1904–1988) gave a speech, titled "Ireland: A Way For Peace?," at the World Affairs Council of Philadelphia in 1985. Jane Duffin, editor of the *Irish Edition*, Philadelphia's monthly newspaper, photographed him for the paper. Born in Paris to exiled Irish parents, his father, John MacBride, was executed for his role in the Easter Uprising of 1916, and his mother, Maud Gonne MacBride, was repeatedly jailed during the Irish Civil War. In 1961, he founded Amnesty International. He drafted the MacBride Principles in 1984, which were aimed at forcing US companies operating in Northern Ireland to ensure equal employment for Roman Catholics. (*Irish Edition*.)

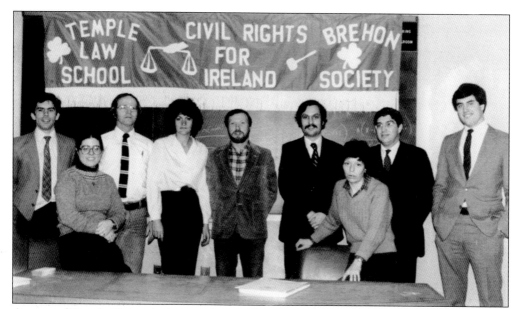

A group of Temple University Law students gathered together in 1982 at a meeting of the Brehon Law Society. Those pictured are, from left to right, Joe Stanton, Jane Duffy, Mike McCreesh, Kass Lovett, Pat Cutter, Jerry Williams, Patti Vanni, Pat Egan, and Kevin O'Malley. Since 1976, the Brehon Law Society has provided a vehicle to promote professionalism in the law for those of Irish descent. The Brehon Law Society greets visiting dignitaries from Ireland and marches in the St. Patrick's Day Parade. (*Irish Edition.*)

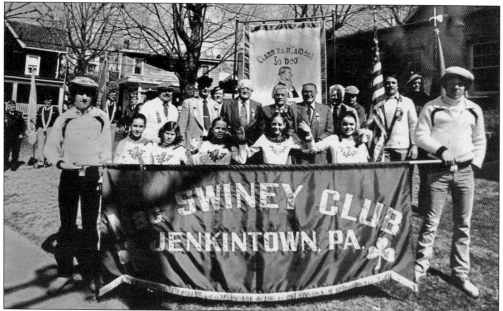

Local officials of the Clan na Gael posed with Timoney Dancers next to the MacSwiney Club in Jenkintown outside of Philadelphia after their annual Thanksgiving Mass. The club was named to honor Terence MacSwiney (1879–1920), the mayor of Cork who died on a hunger strike. The club evolved from Camp 100, Clan na Gael. Matthew Regan, whose father participated in the Irish Civil War, has housed a veritable museum of the Clan na Gael in his clubhouse. (MacSwiney Club.)

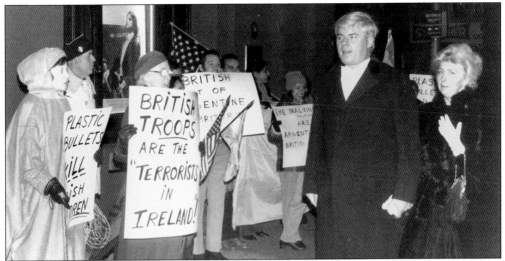

Sir John Oliver Wright (1922–2009), British ambassador to the United States, attended the 126th anniversary Philadelphia Orchestra Concert at the Academy of Music on January 22, 1983. He and his wife, Marjory, were guests of Walter Annenberg, the wealthy former ambassador to Great Britain. They were greeted by 250 protestors against the British rule in Northern Ireland. Some Philadelphia Irish groups supported Sinn Féin, the political arm of the nationalists Irish Republican Army (IRA). (*Irish Edition.*)

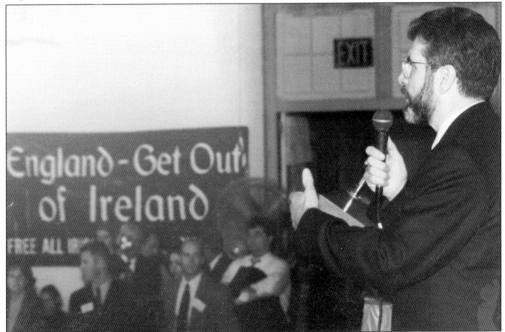

Longtime Belfast resident Gerry Adams came to Philadelphia on October 6, 1998, to speak to his Philadelphia supporters at the Irish Center. Earlier he had spoken at two Irish pubs, the Plough & the Stars and Finnigan's Wake. Adams, born in 1948, celebrated his 50th birthday at the Irish Center. Under his leadership of Sinn Féin, the 1998 Good Friday Peace Accord was signed. Sinn Féin moved away from being a paramilitary wing of the Provisional IRA to becoming an organized political party. (Keenan.)

Five

CITY OF SAINTS AND SCHOLARS

Archbishop Patrick John Ryan (1831–1911), born in County Tipperary, was named the second archbishop of Philadelphia on June 8, 1884, after the death of Archbishop James Frederick Wood. Ryan erected 170 churches and 82 schools. Ryan erected 170 churches and 82 schools. He oversaw a rise in the Catholic population from 300,000 to 525,000. During his tenure, Roman Catholic High School for Boys was built, St. Joseph's House for Homeless Boys was founded, St. Vincent's Home and Maternity Hospital was opened, and the city's three Catholic hospitals—St. Joseph's, St. Mary's, and St. Agnes—were doubled in size. (PAHRC)

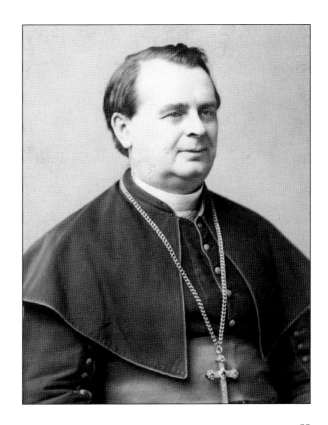

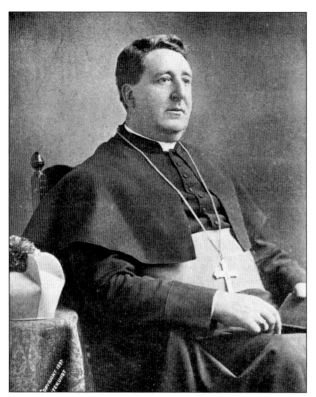

Edmond Francis Prendergast (1843–1918), born in Clonmel, County Tipperary, enrolled at the age of 17 in St. Charles Borromeo Seminary. He was ordained to the priesthood by Bishop James Frederick Wood in 1865. In May 1874, he became pastor of St. Malachy Parish, where he served until 1911. Following the death of Archbishop Ryan in February 1911, Prendergast was named the third archbishop of Philadelphia by Pope Pius X on May 27, 1911. Known as a master builder, he purchased tracts of land for new parishes. (PAHRC)

Bishop Kenrick knew that the Irish Community was spreading west toward Broad Street above Vine Street from their enclaves in Southwark, Moyamensing, Kensington, and Port Richmond. In 1850, there were 72,312 Irish-born in Philadelphia, making up 18 percent of the total population. Kenrick appointed Rev. John F. Kelly to organize a new parish to be called St. Malachy after the 12th-century bishop of Armagh. On May 25, 1851, Kenrick laid the cornerstone for St. Malachy Church at Eleventh Street above Master Street. (PAHRC)

Renovations during the year 1900 that were carried out by the architect Henry D. Dagit included an exterior bell tower. A new Byzantine dome towered over the magnificent main altar with its Carrara marble inlaid with Connemara marble shamrocks. Stained-glass windows were installed honoring Irish donor families, including Boyle, Devlin, Devir, O'Neil, Lynch, Kelly, Mallon, and Fitzpatrick. Then Rev. Edmund Francis Prendergast led the parish for 37 years from 1874 until 1911. (PAHRC)

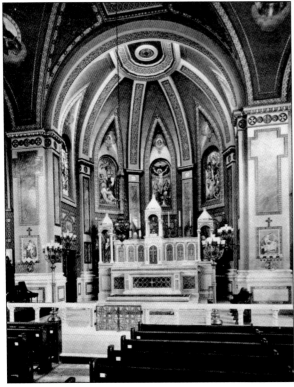

St. Malachy's remodeled sanctuary looked like the old cathedral churches on the east coast of Italy. Michael Magee erected the main altar done in the Byzantine style in memory of his wife, Margaret A. Magee. The Connemara marble shamrocks dominate the design inset into white Carrara marble along with the colored- and gold-glass mosaics. The sanctuary floor, wainscoting, and rail all contain these shamrocks. The massive bell placed in the church tower was made at the McShane Foundry. (PAHRC)

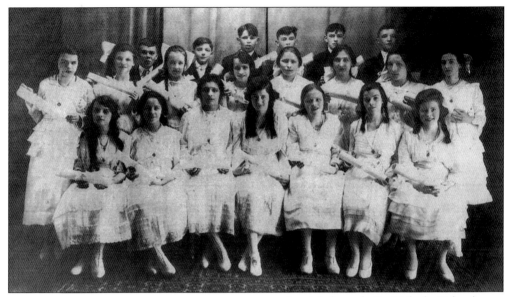

An eighth-grade St. Malachy School graduation photograph, taken in 1916, showed a preponderance of female students. At the turn of the century, there were 533 children enrolled in the eight-year school with nine teachers from the Sisters of Mercy order. At that time, Mother M. Edmonda Prendergast was the principal. (St. Malachy.)

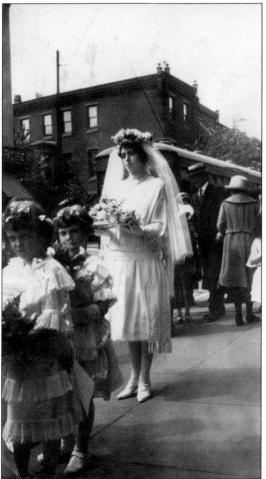

In St. Malachy's 1922 May procession, Regina Cavanaugh dressed in white like a bride and carried a floral crown through her parish neighborhood to crown a Statue of Mary. By the 1920s, most descendants of the famine were thoroughly American, and girls like Regina bobbed their hair. In 1930, Fr. John Henry Martin, newly appointed as St. Malachy's pastor, promoted female education when he helped to found the Mercy Technical Institute, now Mercy Vocational High School. (St. Malachy.)

Fr. John McNamee became the seventh pastor of St. Malachy in 1982. His book *Diary of a City Priest* (1993) was transformed into a movie starring the actor David Morse as McNamee. The Philadelphia Festival of World Cinema premiered this movie in May 2000. McNamee has worked for 20 years to keep the church and school opened in a rough inner-city neighborhood. He has been a mentor, servant, and guide for the urban poor. (*Irish Edition.*)

Irish poets, along with renowned local attorney William Fitzpatrick, meet to hear the first reading of *Tardy Homage to Gerard Manley Hopkins* by the famous Jesuit peace activist, Rev. Daniel Berrigan (center), in 1993 at St. Malachy Church. Father McNamee (left), already a published author, would go on to publish a fourth book, *Donegal Suite: A Collection of Poetry*, in 2006, which was about County Donegal, his "long dead father's place." (*Irish Edition.*)

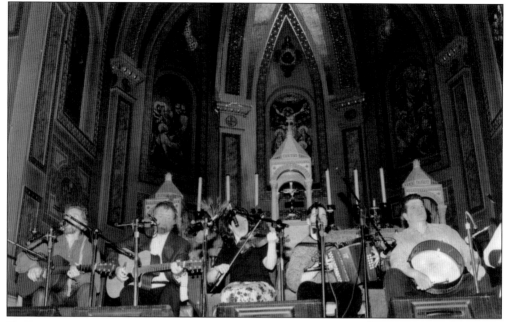

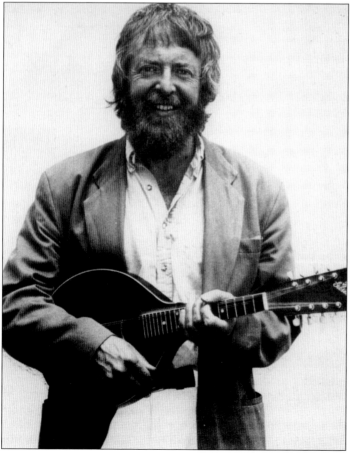

In 1987, Limerick-born musician, musicologist, and folklorist Mick Moloney along with Seamus Egan and Eugene O'Donnell started a tradition at St. Malachy Church, the annual Irish Music Concert. The concert, a fundraiser for St. Malachy School, is put on the Sunday before Thanksgiving. In a 1999 concert photograph, Mick Moloney (second from the left) played with Tommy Sands on guitar and Austin McGrath on bodhran. McGrath owns the Plough & the Stars pub. Mick Moloney has earned a doctorate in folklore from the University of Pennsylvania and has taught Irish studies courses at Villanova University, Georgetown University, and, currently, New York University. (Both, Keenan.)

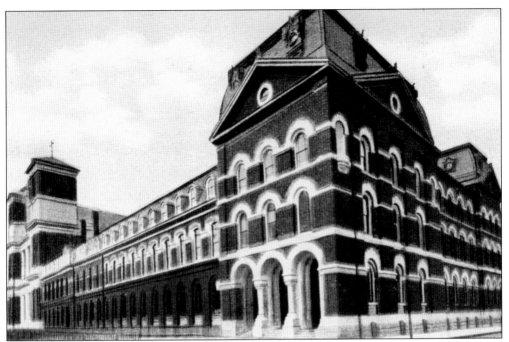

Opened in 1868, the small chapel Gesu was built on land purchased by the Jesuit priest Fr. Felix Barbelin. The land covered an entire city block between Seventeenth and Eighteenth Streets and Stiles and Thompson Streets. From 1873 to 1899, the Jesuits built and expanded St. Joseph's Preparatory School as well as the Church of Gesu. With the help of a $72,000 gift from the will of financier Francis A. Drexel, Gesu was dedicated on December 2, 1888. Church architect Edward F. Durang modeled the building after the Jesuit Church of the Gesu in Rome. (PAHRC)

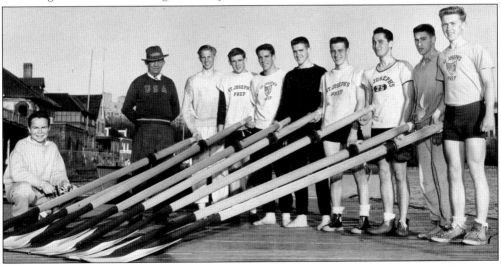

In April 1956, St. Joseph's Preparatory, "the Prep," oarsmen were the defending national champs in eight-oared shells. Under coach Jim Manning, the predominately Irish American team won the US scholastic eights title at the 21st annual National Championship races held in May 1955 on the Schuylkill River. Seen here with coach Manning in front of the Vespers Boat Club are, from left to right, John Quinn (coxswain), Joe Heimerl, Jack Whalen, Harry Haloran, Jack King, Fred Plefka (captain), Jim Connor, Mike Breslin, and Ed Duckworth. (PAHRC, Halvey)

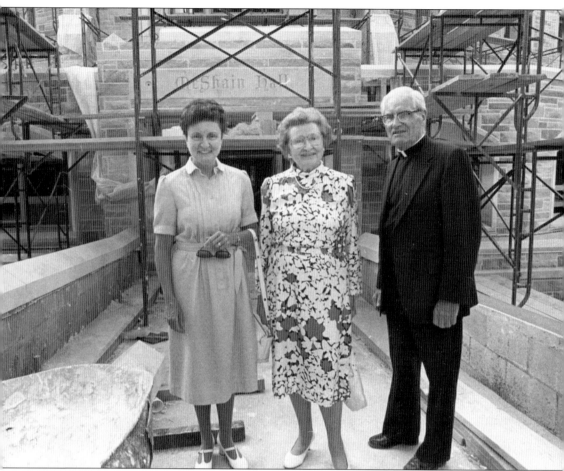

In 1989, John McShain's daughter Sister Pauline and his wife, Mary McShain, stood on the newly constructed McShain Hall Pedestrian Bridge with Rev. Michael J. Smith, S.J., special assistant to the university president. The landmark bridge spans City Line Avenue and connects the Philadelphia campus of St. Joseph's University with McShain Hall situated on the Lower Merion campus. John McShain (1898–1989) graduated from St. Joseph's Preparatory School in 1919. Starting in the 1930s, his Philadelphia-based construction company landed major projects in Washington, DC, including the construction of the Pentagon and the White House renovation in 1950 to 1952. The McShain Charities, organized in 1944, has made substantial donations to Catholic colleges and parochial schools. (PAHRC)

The headquarters of the American Catholic Historical Society originally was located at 715 Spruce Street. Its current headquarters is 263 South Fourth Street. In July 1884, Irish historian and priest Martin I.J. Griffin along with a group of Catholic professional editors formed a society to collect, research, record, and maintain historical documents and artifacts. Since 1884, the *American Catholic Studies* has been published, making it the oldest, continuously published American Catholic scholarly journal. (PAHRC)

From a prominent Irish family, Rev. Msgr. Bernard A. McKenna (1875–1960) (left) served as the president of the American Catholic Historical Society from 1941 to 1944. He greeted Irish American Prelate Rev. Joseph Carroll McCormick (1907-1996) (right). Rev. McCormick and Msgr. McKenna attended a meeting of the ACHS at Holy Child Hall on December 1, 1941. (PAHRC, Halvey)

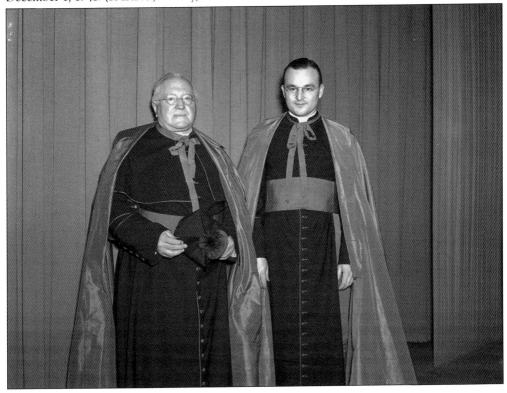

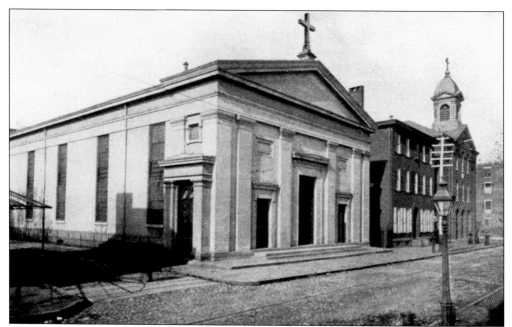

The first St. Patrick's Church, erected in 1841, was located at the northwest corner of Twentieth and Rittenhouse (now Locust) Streets. Napoleon LeBrun, the builder of the Cathedral of SS. Peter and Paul, was the architect. The parish organized in 1839 served primarily Irish laborers who worked at the coal shipyard on the east bank of the Schuylkill River. On May 6, 1844, at the time of the Nativists' riots, the Irish parishioners of St. Patrick's Church saved the church from being burned to the ground. (PAHRC)

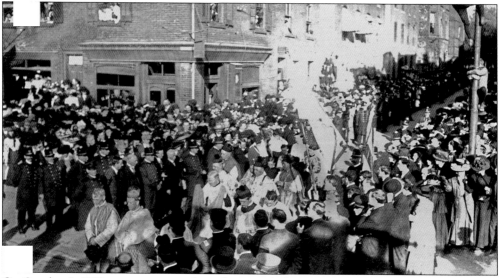

On October 2, 1910, in a procession through a crowd of 40,000, his Eminence Cardinal Michael Logue, archbishop of Armagh and Primate of All Ireland, laid the cornerstone for the new St. Patrick's edifice. The city's mayor, John Edgar Reyburn (1845–1914), sat with Bishop Prendergast and Archbishop Ryan on the platform. The cornerstone, a true "Rock of Erin," was a block of marble sent from the See of Armagh, quarried from the rock on St. Patrick's hill where Ireland's patron saint preached. (PAHRC)

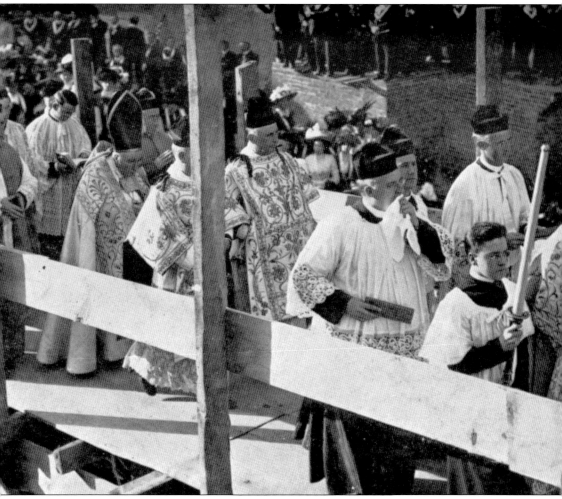

Cardinal Logue was a personal friend of St. Patrick's pastor, Msgr. William Kieran, since both men hailed from the See of Armagh. The new church was built in a now affluent and fashionable neighborhood close to Rittenhouse Square. A salient new feature included a massive porch at the Twentieth Street entrance on the top of which was carved "Deo Dicatum. In Honorem Sti. Patricii," meaning "dedicated to God in honor of St. Patrick." (PAHRC)

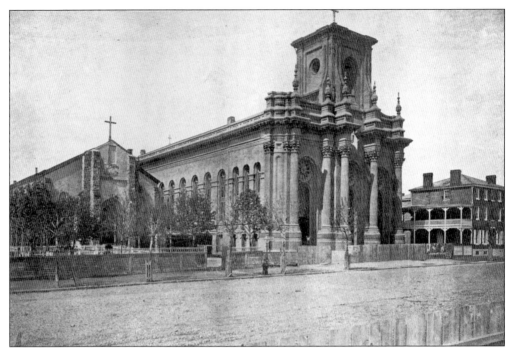

Many Irish immigrants moved to Port Richmond around 1842 to work in the anthracite coal trade. In 1845, Bishop Francis P. Kenrick bought land from Catholic lawyer George Edwards and established a new parish called St. Anne Parish. Napoleon LeBrun (1821–1901), architect of the Cathedral of SS. Peter and Paul, designed the first church. Rev. Hugh McLaughlin became the first pastor. In 1870, the mainly Irish congregation built this larger church in the Italian Renaissance style, which was gutted by a fire in 1947. (PAHRC)

In front of St. Anne Church, the 1944–1945 first-grade children of the parish school posed for a class photograph. The parish and school system promoted solidarity for the Irish that allowed them to go from cradle to grave surrounded by other Irish Catholics. St. Anne's children, predominately first-generation Irish, were a part of a parish community, and their early identities were shaped by Catholic moral and intellectual values. Irish Catholics rarely went to public schools in Philadelphia. (PAHRC)

St. Columba Church was located in the Irish neighborhood known as Swampoddle from 1894. Irish-born Rev. Walter P. Gough laid the cornerstone of St. Columba on June 20, 1906, with over 25,000 people in attendance. The cornerstone was cut and dressed in Donegal, the home of Irish St. Columba. Joseph G. Roddy, a 1949 graduate of St. Columba Parochial School, self-published a loving account of being a student at the school. His 2010 memoir was called *Growing Up In Heaven: The Journey of an Irish Immigrant Family in Philadelphia.* (PAHRC)

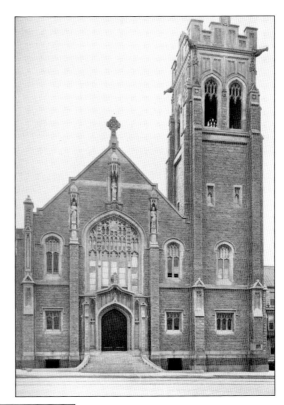

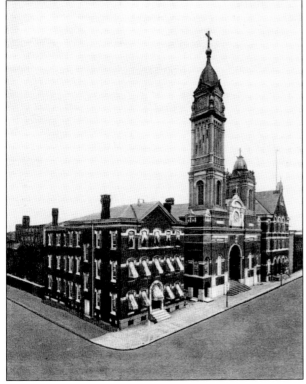

The rebuilt St. Michael Church rose from the ashes of the first St. Michael consumed by fire during the Nativists' riots in Kensington. The parish successfully sued the County of Philadelphia for damages and won a judgment that provided the funds to build another church. The parochial school was operated at first by the Sisters of Charity and, later in 1859, the Sisters of St. Joseph. Kensington attracted large numbers of Irish who came because of the ready availability of jobs in wharves and factories. (PAHRC.)

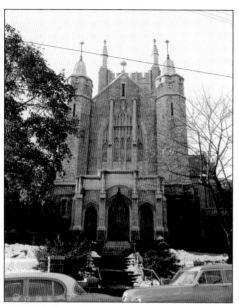

Around 1840, St. Bridget Church started as a mission church of Nicetown's St. Stephen's Church. The predominately Irish parishioners, many of whom worked in nearby textile manufacturer Dobson Mills, worshiped in the Falls of the Schuylkill Village Hall. In 1853, Fr. James Cullen raised the funds to build a simple church. In 1870, Reverend Fox expanded this building. In 1910, with the growth of the affluent East Falls neighborhood, Msgr. W.J. Walsh hired architect George Ignatius Lovatt (1872–1958) to erect a Gothic church on Midvale Avenue and Stanton Street. (PAHRC)

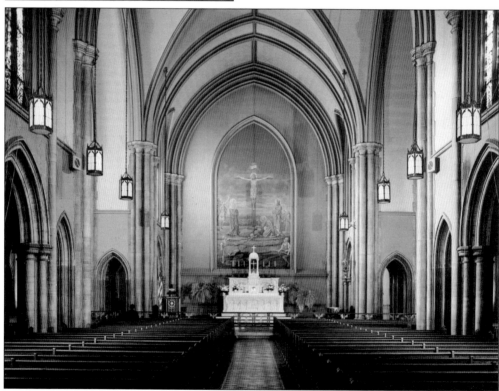

In 1953, St. Bridget Church on Midvale Avenue in East Falls prospered with Irish parishioners, such as the legendary baseball player "Connie Mack," born Cornelius McGillicuddy, and John B. Kelly Sr., Olympic oarsman and owner of the largest brickwork company in the United States. Mansions built by socially prominent Irish Catholics dotted the parklike neighborhood. The St. Bridget community became the hub for the emerging class of powerful city business owners, judges, and city politicians who claimed Irish ancestry. (PAHRC)

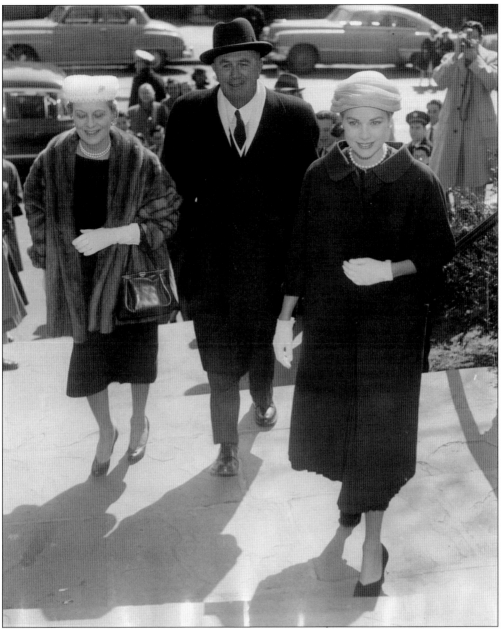

On April 2, 1956, John Brendan and Margaret Katherine Kelly arrived with their daughter, the bride-to-be Grace Kelly, for Easter Sunday Mass at St. Bridget Church. The family worshiped at St. Bridget Church in East Falls. She would be married two weeks later in Monaco's St. Nicholas Cathedral to Prince Ranier III. John B. Kelly built his home at 3901 Henry Avenue where his four children, including John B. Kelly Jr. and Grace grew up. After her marriage, Grace Kelly often returned home and attended services at St. Bridget. Academy award–winning Grace Kelly began her acting career at Old Academy Playhouse, a small East Falls theater. (Temple University Urban Archives.)

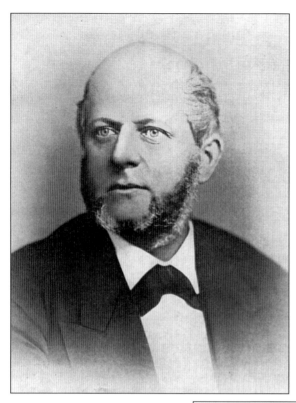

Thomas E. Cahill (1828–1878), born in the Irish enclave known as "Ramcat" near Twenty-sixth and South Streets behind Rittenhouse Square, operated a coal and lumber business on the banks of the Schuylkill River. He amassed a fortune and left his wealth to build a secondary school for boys, Roman Catholic High School. It was the first free Catholic high school in the United States. It opened in 1890. (Special Collections, Villanova University.)

Roman Catholic High School, located at what is now 301–313 North Broad Street, was built by the prominent architect Edwin Forrest Durang. The Gothic building was constructed of stone with a superstructure made of white marble, which rested on a foundation of granite. Additional Catholic secondary schools were planned by the following superintendents: Rev. John H. Shanahan, from 1894 to 1899; Rev. Philip R. McDevitt, from 1899 to 1916; and Rev. John E. Flood, from 1916 to 1922. These schools included West Philadelphia Catholic High School (1916) and Northeast Catholic High School for Boys (1926). (Special Collections, Villanova University.)

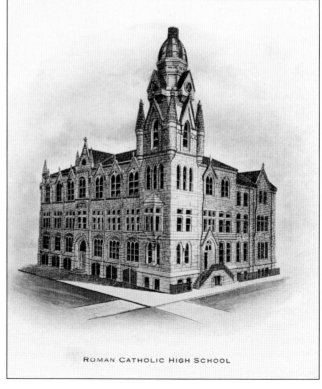

ROMAN CATHOLIC HIGH SCHOOL

On December 10, 1953, the Roman Catholic High School class of 1923 had a reunion at the Catholic Philopatrian Club, also known as the "Philo," located at 1923 Walnut Street. Since 1903, students enrolled in the four-year program could choose from three fully developed curricular programs, including a manual skills course, a commercial course, or an academic college-bound course. Roman gained a stellar reputation nationally for its curricula and its mainly religious teachers. (PAHRC)

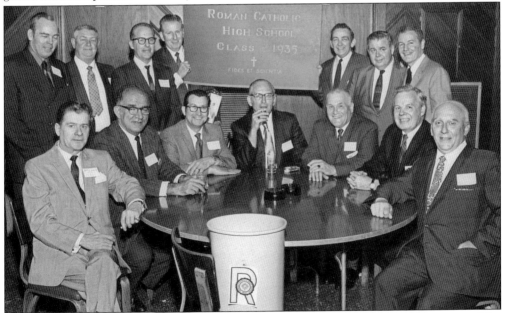

Members of the Roman Catholic High School class of 1935 gathered for a 35th reunion on May 17, 1970, at Cavanaugh's Bar, a famous Irish center-city meeting place for Catholic high school alumni groups. In 1985, the alumni association saved the school from closure and supported the historic landmark designation of the building. A few notable Irish alumni include Rev. Msgr. John J. Bonner, class of 1908, diocesan superintendent of schools, and James P. McGranery, class of 1913, attorney general under Pres. Harry Truman from 1952 to 1954. (PAHRC)

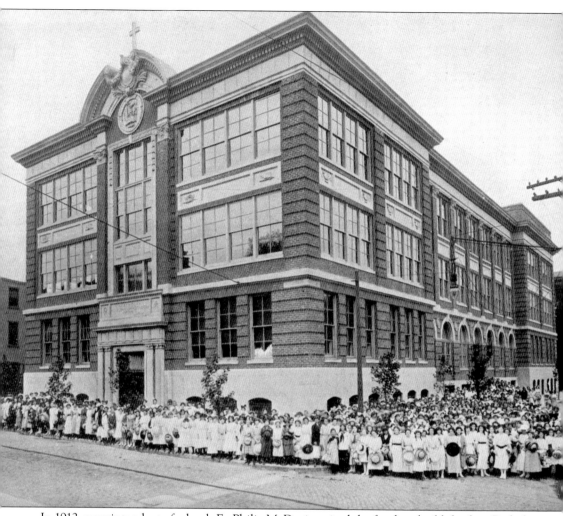

In 1912, superintendent of schools Fr. Philip McDevitt raised the funds to build the first Catholic high school for girls, which was initially called Catholic Girls' High School. An important Irish donor was Mary Hallahan McMichan (1861–1925). She transferred $100,000 from the estate of her brother John W. Hallahan. The school was named John W. Hallahan Catholic High School for Girls in honor of Mary McMichan's deceased brother. Other all-girls high schools built included Little Flower Catholic High School for Girls (1939), St. Hubert Catholic High School for Girls (1941), and St. Maria Goretti High School for Girls (1955). (PAHRC)

On February 25, 1964, the Alumni Newman Club of Greater Philadelphia's president, William H. Hansell, awarded its fifth Newman award to Dennis Clark (1927–1993), who at the time was enrolled in the graduate history department of Temple University. Dennis Clark received two history degrees from Temple University, a masters in 1966, and a doctorate in 1970. The club established in 1959 had members who attended local, non-Catholic universities and took its name from Cardinal John Henry Newman. (1801–1890.)(PAHRC, Halvey)

Charles A. Heimbold Jr. (right) endowed the chair of Irish Studies at Villanova University in 2000. Dr. James Murphy (left), director of the program, initiated Villanova's Irish Studies Program in 1979 with the guidance of Dr. Dennis Clark. At center, Emily Riley, daughter of John F. Connelly, attended representing the Connelly Foundation. Enrolled in the doctorate program at Temple University, Murphy studied with Clark who later assisted Murphy with the startup of Villanova's interdisciplinary program. (Keenan.)

Joseph Middleton, a descendant of well-to-do Irish Quakers and a Catholic convert, founded Chestnut Hill's parish, Our Mother of Consolation, in 1855. The famine Irish lived in the Chestnut Hill area as domestic servants in the mansions of the Anglo-Saxon Protestants in this exclusive, northwestern neighborhood. In 1858, the Sisters of St. Joseph bought Joseph Middleton's mansion, Monticello, on a seven-acre tract of land where they established their motherhouse. They founded Mount St. Joseph's Academy in 1871 and Chestnut Hill College for Women in 1924. (PAHRC)

On May 10, 1986, Seamus Heaney came to Chestnut Hill College to give a poetry reading. Pictured are, from left to right, Bernard Croke, director of the Irish American Cultural Institute; unidentified sister of St. Joseph; Seamus Heaney; and Lester Conner (1921–2005), English professor at the college. Born in Northern Ireland, Heaney went onto win the 1995 Nobel Prize in Literature. (PAHRC)

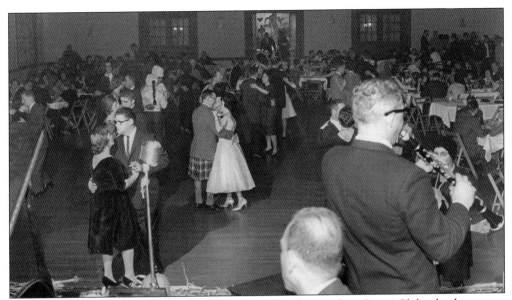

A favorite choice for student dinner-dances was the Commodore Barry Club, also known as the Irish Center, located in West Mount Airy. Here, LaSalle College evening students step out with their dates at a senior social masquerade dinner-dance on November 9, 1963. The evening program required six years of study, permitting the students to work their way through school. The senior-class officers of the evening classes of 1963–1964 included Frank Johns, Bill Glancey, Joe Murphy, and Art Martinelli. (PAHRC, Halvey)

Joseph F. Sinnott (1837–1906) lived in this home on Walnut Street between Forty-second and Forty-third Streets. He built a much grander home, Rathalla, in Rosemont in 1891, which became the centerpiece of Rosemont College. Born in Donegal, he owned one of the United States' largest distilleries. (Rosemont College Archives.)

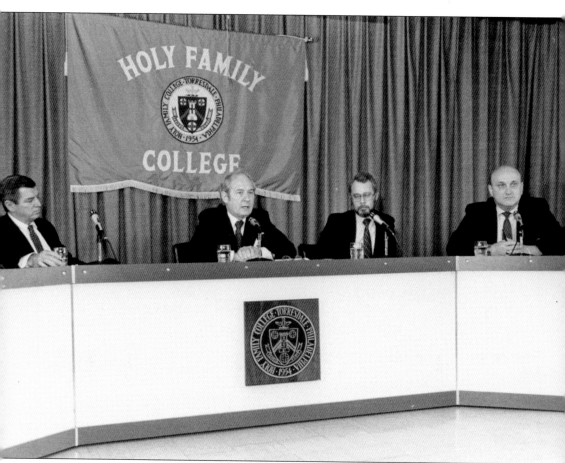

Tadhg O'Sullivan (center), ambassador of Ireland to the United States, gave a talk, titled "Northern Ireland—the Tragedy Continues," on March 29, 1985, at Holy Family College. O'Sullivan spoke of the two groups of Irish, those on his island and those in America. O'Sullivan served as ambassador of Ireland from 1978 to 1984. Former Republican member of the US House of Representatives Charles F. Dougherty (first on right) participated. (PAHRC)

Six

BUILDING THE
HIBERNIAN COMMUNITY

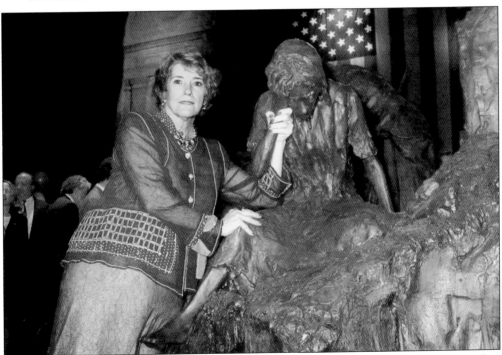

On October 19, 2002, the unveiling gala for the Irish Memorial took place at Turbine Hall in Chester. Pictured is Kathy McGee Burns, a member of the Irish Memorial Committee Board of Directors. She clutched the hand of a bronze figure of a dying victim of An Gorta Mor, meaning "the Great Hunger," when over two million Irish people died of starvation or forced emigration. The dynamic design is a wedge with the higher end suggestive of a ship, which faces toward America, and the lower end, which faces toward Ireland, dotted with Celtic crosses. (Keenan.)

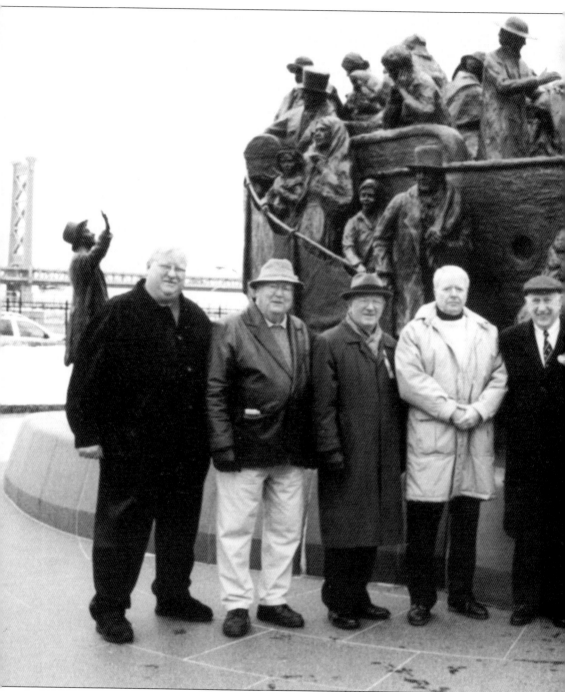

Dr. Dennis Clark thought the Society of the Friendly Sons of St. Patrick should commemorate the sesquicentennial of the Great Irish Famine (1845–1850). Following Clark's suggestion, James J. Coyne Jr. formed the Irish Memorial Committee in 1991, which started up a new organization, Irish Memorial, Inc., with Coyne as its first president. Working with several entities, including the Fairmount Park Commission, the City of Philadelphia, and the Philadelphia Art Commission among others, Coyne selected a 1.75-acre park along the waterfront. Renowned sculptor Glenna

Goodacre and landscape design architect Pauline Hurley Kurtz were awarded the commission. It took Coyne 12 years to raise the initial $2.7 million needed for the project. The memorial was opened to the public October 25, 2003. Board members pictured here on March 17, 2004, include, from left to right, Robert M. Gessler, John J. O'Connell III, Robert S. Hurst, Drew J. Monaghan, James J. Coyne Jr. (president), Kathleen M. Sullivan, John F. Donovan (vice president), Hon. Edward J. Bradley, Edward P. Costello, and Francis J. Moran, Esq. (general counsel). (Keenan.)

Anthony Robert "Tony" Byrne (1932–) is the owner and founder in 1981 of *Irish Edition*, Inc., an Irish American newspaper. He was educated in local parochial schools, St. Joseph's College, the Wharton School, US Navy Flight School, Pensacola, and University College Dublin. While living in Japan for a year, he earned a diploma in Ikebana and exhibited in Yokohama. His real education came in the US Marine Corps where he was a naval aviator and while with Air America, Inc., in Southeast Asia. From 1965 to 1974, he was a captain and instructor pilot with Air America, Inc. He flew on or led hundreds of special operation missions in Laos, South Vietnam, North Vietnam, Cambodia, China, and Thailand. After being rescued after one of the times he was shot down in Laos, he spent time recuperating in a Buddhist monastery near Udorn, Thailand. The head monk was a religious teacher to the Queen of Thailand and he kept a pet cobra, which lived under his hut at the monastery. (*Irish Edition*.)

The Society of the Friendly Sons of St. Patrick struck a gold medal in 1772, one year after the society's founding in 1771. The medal is still worn by society officers and members. This symbol of membership has on its front the female figure of liberty joining the hands of Hibernia with a harp and a Native American, representing the United States, over the word "unite." On its back is St. Patrick as he tramples on a snake, with cross in hand and dressed in pontifical robes, over the word "Hier," the Gaelic for Ireland. (Krivda.)

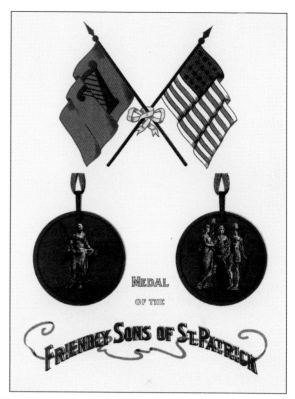

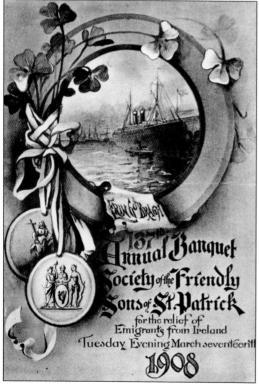

The cover for the 137th annual banquet of the Society of the Friendly Sons of St. Patrick for the Relief of Emigrants from Ireland was held at the Bellevue Stratford Hotel on March 17, 1908. Society president Thomas J. Stuart welcomed Philadelphia's Mayor John E. Reyburn (1845–1918) and Gov. Edwin Sydney Stuart (1853–1937). Founded in 1771, the society is the oldest continuing Irish organization in the United States. Its first charter dated April 27, 1792, and later, its name changed to the Hibernian Society for the Relief of Emigrants from Ireland. It reverted to its original name, the Society of the Friendly Sons of St. Patrick in 1892. (PAHRC)

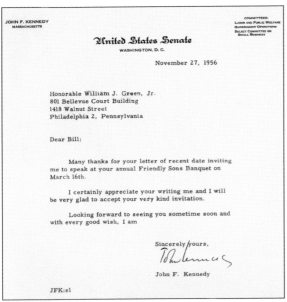

United States Senate

WASHINGTON, D.C.

November 27, 1956

Honorable William J. Green, Jr.
801 Bellevue Court Building
1418 Walnut Street
Philadelphia 2, Pennsylvania

Dear Bill:

Many thanks for your letter of recent date inviting me to speak at your annual Friendly Sons Banquet on March 16th.

I certainly appreciate your writing me and I will be very glad to accept your very kind invitation.

Looking forward to seeing you sometime soon and with every good wish, I am

Sincerely yours,

John F. Kennedy

JFK:el

In a letter dated November 27, 1956, junior senator John Fitzgerald Kennedy accepted an invitation from the Society of the Friendly Sons of St. Patrick to speak at the 1957 St. Patrick's Day dinner. Kennedy appeared before 800 guests at the 186th annual Friendly Sons dinner on March 16, 1957, at the Bellevue Stratford Hotel. Kennedy's stirring speech compared the Irish struggles for independence and devotion to liberty with those of other colonial dependencies in America, Africa, and Eastern Europe. (Historical Society of Pennsylvania.)

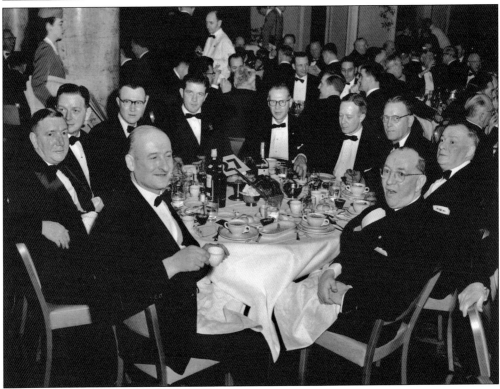

On April 23, 1957, a testimonial dinner for the first Jewish lord mayor of Dublin, Robert E. Briscoe (1894–1969), was held at the Benjamin Franklin Hotel. The City of Philadelphia sponsored the dinner and invited many Jewish business leaders as well as members of various heritage groups, including officers of the Society of the Friendly Sons of St. Patrick, seen here. As a young man, Briscoe was active in the Irish Republican Army and Sinn Féin. He accompanied Éamon de Valera to America. (Historical Society of Pennsylvania.)

The Irish American Club was a social and patriotic association, which maintained its headquarters at 1428 North Broad Street, next to the Mercantile Hall. The group was known not only for giving aid to immigrants, but also for supporting the Clan na Gael and the IRA. Meetings were held at 3:00 p.m. on Sundays on the second floor, and if members came late, they had to give a password before going upstairs. The club celebrated Irish culture through live performances of Irish music. Regular Irish dances took place on the first floor, but the larger balls were held in the ballroom of the Mercantile Hall. (PhillyHistory.org.)

The charter for Division No. 39 of the Ancient Order of the Hibernians of Tacony in Philadelphia County was granted on May 11, 1888. Division No. 39, named for Msgr. Thomas J. Rilley and located at 7229 Tulip Street, celebrated its 100th anniversary in May 1989. The first AOH Division was founded at New York's St. James' Church on May 4, 1836. Started as a secret, fraternal society restricted to Irish-born Catholics, it later admitted sons of Catholic immigrants. (Ancient Order of the Hibernians.)

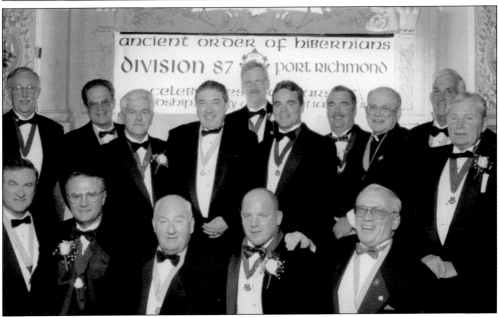

Division No. 87, headquartered in Port Richmond, has been guided by the national AOH motto: "Friendship, Unity, and Christian Charity." Seamus Boyle, member of AOH Division No. 39, was elected to be the current national president in 2008. Born in County Armagh, he left Northern Ireland with his father who was hired by local builder, Matthew McCloskey. Boyle became business agent for the Philadelphia Council of Carpenters and joined Division No. 87 in 1972. In 1987, Philadelphia hosted the state convention. In the back row, fourth from the left, Boyle is seen with AOH leaders. (*Irish Edition.*)

In February 2010, Pennsylvania Supreme Court justice Seamus McCaffery held a resolution from Philadelphia's city council urging England and Ireland to uphold the Good Friday Accord. Ancient Order of the Hibernians' national president Seamus Boyle stood beaming behind the resolution. Liz and Pearse Kerr of Jenkintown have been veterans of the struggle. Pearse was wrongfully arrested in Belfast but was released after three months of imprisonment with the help of Jack McKinney, a *Daily News* columnist, and Northeast congressman Joshua Eilberg. (Keenan.)

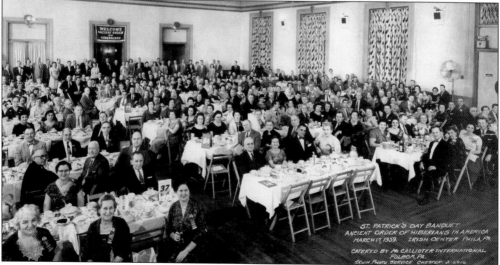

The St. Patrick's Day Banquet of the Ancient Order of the Hibernians was held on March 17, 1959, at the Commodore Barry Club. From the early 1900s, all AOH members have been eligible for life insurance, relief, and sick benefits. The national AOH has distributed over $37 million in sick benefits, $13 million in death benefits, and over $20 million for charitable purposes. A number of ladies' chapters (LAOH) have been founded in Philadelphia. (Irish Center.)

In 1958, the Commodore Barry Club, more commonly known as the Irish Center, was started by two tavern-keepers, Mickey Cavanaugh and Michael Scullion. They located and purchased a large rambling building in Mount Airy at Carpenter and Emlen Streets with several bars, restaurant facilities, meeting rooms, and an auditorium. A corporation was chartered as Commodore John Barry, Inc., with 1,000 shares of stock issued for a capitalization of $100,000. Irish county societies, in particular the Donegal Society and the Mayo Society, promoted the club with the hope of growing their membership. Prior to the Irish Center, the Irish American Club, located at 1428

North Broad Street, served as a meeting place but had a strong political agenda having been a creation of the Clan na Gael. When the Irish Center opened, it had a nonpolitical mission, which was to provide a common Irish social facility where county societies could hold large fundraising balls, meetings, concerts, and other events. For over 50 years, the Irish Center has promoted Irish culture with regular Friday night dances of the Philadelphia Céilí Society, Gaelic language lessons, lectures, and traditional Irish music concerts. (Keenan.)

Seamus "Jim" McGill, born in Ardara, County Donegal, arrived in the United States at the age of 17. In 1958, McGill was one of the original founding members of the Philadelphia Ceílí Group, serving as its president numerous times. He has been head of the local Comhaltas Ceoltóirí Éireann, which promotes traditional Irish music, and was managing director of the Irish Center for over a decade. Jim is pictured with his wife, Mickey. (*Irish Edition*.)

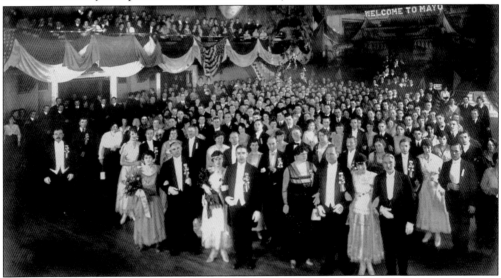

On January 22, 1917, the Mayo Men's Beneficial, Social, Patriotic, and Literary Association of Philadelphia held their 11th annual ball at Mercantile Hall, a Gilded age–style private club on Broad and Master Streets. The officers of the ball were Joseph P. Kerrigan (chairman), James Clance (secretary), and Nicholas T. Glynn (treasurer). As early as 1901, men with roots in rural County Mayo worked together to assist emigrants and descendants of emigrants to adjust to life in industrial Philadelphia. Three Mayo men, John O'Neill, Marin Clarke, and John Green, wrote the Mayo Men's constitution. The Mayo Association celebrated its 100th anniversary in 2005. (Irish Center.)

In 1949, the O'Malley family attended the Mayo Ball held at the Broadwood Hotel at the corner of North Broad and Wood Streets. Thomas O'Malley Sr. held his son Thomas O'Malley Jr. alongside his wife and sister. Thomas P. O'Malley Jr. went on to become president of the Mayo Society (1987) and the Society of the Friendly Sons of St. Patrick (2000). The society's philanthropy started in the early 1900s when members provided economic assistance for needy passengers on ships coming from Ireland to Philadelphia. (Irish Center.)

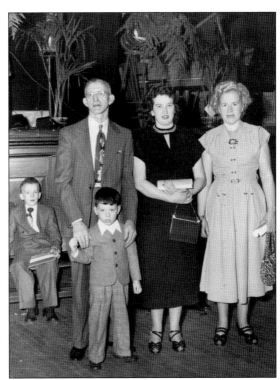

Seen here in 1967 at Cavanaugh's Railroad Bar at 3128 Market Street was Patrick J. Stanton, owner of WJMJ 1540 radio. Cavanaugh's hosted the swearing in of Tommy Moffit as the new president of the Mayo Association. The bar was a popular stopping point for campaigning politicians for over half a century until it closed in June 1988. It was owned by Patrick Cavanaugh. (Irish Center.)

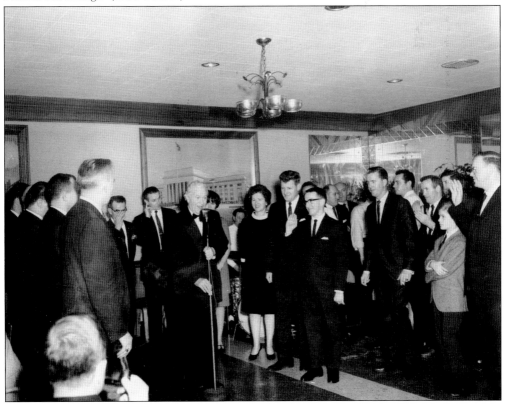

The star of the 1955 Golden Jubilee Ball of the Mayo Association was John "Jack" B. Kelly Jr., the son of John "Jack" Kelly Sr., the wealthy brick manufacturer and Olympic rowing champion. Jack Jr. worked in the family business while serving for 12 years on city council and was also president of the Philadelphia Athletic Club and the Pennsylvania Ballet. The annual Mayo Ball was the high point of the association's social season and the largest money raiser for its various charities. (Irish Center.)

At the 1987 Mayo Ball, Attracta O'Malley was escorted by her husband, Tom, the newly elected president of the Mayo Association. Born in Charlestown, Mayo, she formed the Ladies Auxiliary of the Mayo Association and lobbied for women's admission. In 1981, she became the first woman president and served again in 1998. (*Irish Edition*.)

In 1964, the Mayo Men's Beneficial, Social, Patriotic, and Literary Association of Philadelphia had a new constitution and a new name, the Mayo Association of Philadelphia. In 1966, membership opened up to women of County Mayo by birth, descent, adoption, or marriage. Seen here were the first women members posed in front of the Irish Center with young Sean McMenamin (first row, third from left). McMenamin, the oldest of six, was born in Killadangan, Mayo. He was president of the Mayo Association in 1972, treasurer of the Mayo Association, secretary of the Gaelic Athletic Association, and president of the Irish Center. One of his greatest achievements has been the Irish Library at the Commodore Barry Club, which he established with Billy Brennan and Frank Hollingsworth. (Irish Center.)

The Donegal Beneficial, Social, Charitable, and Patriotic Association was incorporated by charter on July 19, 1892, and held its first meeting on September 18, 1888. Since its founding, the Donegal Society has held its major fundraiser, the Donegal Ball, on the last Saturday in November. It has always been the biggest fundraiser of the year for the society. In 1948, the Society elected young Thomas C. Finnegan as the chairman of the 60th annual ball. (Krivda.)

Barney J. Boyce, president of the Donegal Society and a native of Donegal, danced with his wife, Carmel, at the 1991 Donegal Ball held at the Irish Center. Boyce has served for many years on the Board of the Irish Center where he first met his longtime friend Thomas Finnegan. (*Irish Edition.*)

From left to right, Thomas C. Finnegan, Peter McGinley, and John Conaghan Sr., honored as the oldest members of the Donegal Society, were grand marshals at the Centennial Donegal Ball in 1988. Earlier in May for the 100th anniversary, St. Joseph's University held a two-day celebration, which included Irish hurling and football, lectures, and step dancing. Dr. Dennis Clark wrote a stirring book that paid tribute to the society, *The Heart's Own People: The Donegal Society of Philadelphia, Centennial 1988. (Irish Edition.)*

In 1999, the Donegal Society sponsored this holiday concert and dance to benefit the Irish Center. The centerpiece of the Irish Center has been its great ballroom and large stage. The Irish Center's Jim McGill commissioned local artist Janet McShain to paint on the stage's rear wall a rural mural suggestive of a Donegal road. McShain's mural was called "Echo of Donegal." (Keenan.)

In 2005, Vincent Gallagher, host of the Irish Radio Program and grand marshal of the 54th annual St. Patrick's Day Parade, sat with a delegation of visitors from Letterkenny who visited at the Irish Center after the parade. Pictured are, from left to right, (sitting) Vera Gallagher, unidentified, Theresa Murtagh, Danny Browne, Mary McHugh, Carmel Boyce, and unidentified visitors; (standing) Mike Burns, Kathy McGee Burns, Pat Bainum, Nora Campbell, Steve Lynam, unidentified, Barney Boyce, Mary Crossen, Lawrence D. Kumor, and unidentified visitors from Letterkenny. (Keenan.)

With a beaming smile, Anne McKeon commanded the Irish Center's stage at the 1992 Mary from Dungloe contest. She was crowned at the 103rd Donegal Ball and represented the society for a whole year, including at the 1993 St. Patrick's Day Parade and at the 1993 International Mary from Dungloe pageant in Dungloe, Donegal. (*Irish Edition.*)

The Cavan Men's Catholic, Social, and Beneficial Association was founded on March 17, 1907, as a fraternal group that cared for sick members and helped poorer members with burial expenses. One of the most well-known Cavan men was Congressman Michael Donohoe (1864–1958). On May 20, 2007, the Cavan Society had its 100th anniversary dinner at the Irish Center. (Keenan.)

The Society of the Sons and Daughters of Derry was founded October 27, 1907, at the Grand Army of the Republic Hall on 1363 Ridge Avenue. At the annual Derry Society Ball, Mary Quinn (center) gave an award to honor Project Children's local coordinator Sr. Francis Patrice Kirk (left). Since its founding in 1975, Project Children has funded thousands of Catholic and Protestant children's transportation costs from Northern Ireland to have a vacation with Philadelphia families away from violence. (Irish Center.)

The Tyrone Society of Philadelphia, founded in 1909, marched in the 1954 St. Patrick's Day Parade down the parkway. The men's club proudly carried their brand-new society banner made in Ireland. The banner had in its center the Red Hand of Ulster, an ancient heraldic symbol on the Northern Ireland flag. The Tyrone Society celebrated its 100th gala on April 18, 2009, at the Irish Center. Philomena Begley, Ireland's queen of country music, and Brian Dooher provided the entertainment. (PAHRC, Halvey)

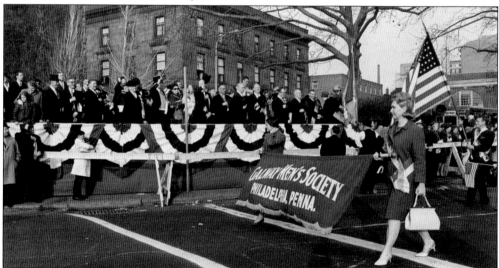

The Galway's Men's Society marched in the 1967 St. Patrick's Day Parade passing the reviewing stand on the Parkway. The Galway Society was founded in March 1909 by a group of 11 immigrants who met in Carpenters Hall. When the Irish Center was purchased in 1959, the society was one of the biggest investors in that venture. It has had a core group that has kept it going, including Billy Brennan, the Egans, Jack Gilmore, and Dan Raftery. The society held Galway's 100th annual dinner-dance in the spring of 2009. (PAHRC, Halvey)

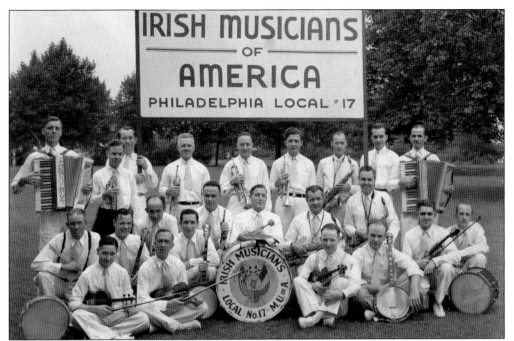

The Irish Musicians of America, Local No. 17, was founded in 1918 in Philadelphia as Irish Musicians Union, Local No. 1. Tommy Caufield (1903–1987), born in Ballinlogh, County Roscommon, served as its treasurer for many years from the 1930s to the 1950s. In 1956, Ed Reavey Sr. (1897–1988) and others founded the Irish Musicians Association of America, and Philadelphia's Local No. 1 became Local No. 17 of the new association. The union set wages to be paid to their members for performances and helped to book musicians for events. (Historical Society of Pennsylvania.)

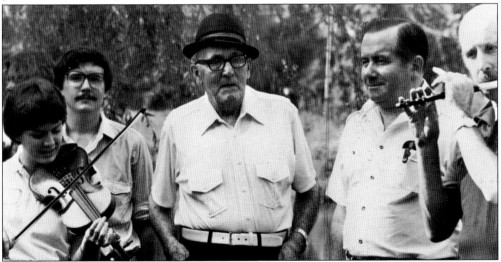

On September 12, 1981, the Philadelphia Céilí Group held its annual Irish Music and Dance Festival at Fischer's Pool. Tommy Moffit (second from right) was a founding member of the Philadelphia Céilí Group in 1958. Edward Revey Sr. (left of Moffit) spearheaded the revival of traditional music. The Céilí Group went beyond the preservation of traditional Céilí and set dancing. It evolved into a major promoter of traditional Irish music sponsoring locals, such as Mick Moloney and Eugene O'Donnell, as well as groups, such as the Chieftains. (*Irish Edition*.)

The Irish American Cultural Institute, Philadelphia Chapter, was founded in 1977 with no political or religious ties. Through its Irish Perceptions program, the IACI has sponsored lectures, musical, and theatrical performances. The Irish Way Program suggested by the late Princess Grace Kelly of Monaco has provided scholarships for local students to study Irish history in Ireland. Since 1966, the national IACI has published a quarterly journal of Irish studies, *Eire-Ireland*. The Irish American Cultural Institute has been based in Morristown, New Jersey. (Krivda.)

The Scotch-Irish Society of the United States was founded in 1889 with the mission of the preservation of Scotch-Irish history. In 1949, the society, headquartered outside Philadelphia in Bryn Mawr, established the nonprofit Scotch-Irish Foundation to preserve books, documents, and historical material of the Scotch-Irish. The Scotch-Irish descended from 200,000 Scottish Lowland Presbyterians who migrated in the 17th century to Ulster. Economic pressures caused many Scotch-Irish to settle in Philadelphia. (Krivda.)

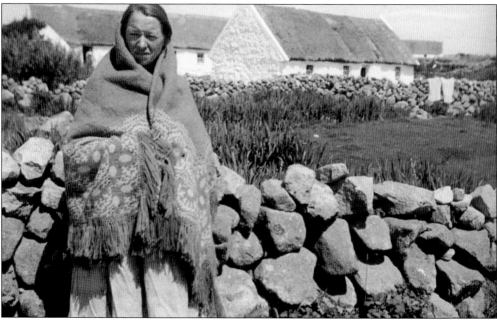

Rosemarie Timoney (on the right), born in Clady, County Derry, marched with the Timoney School of Irish Dance at the annual St. Patrick's Day Parade. In 1966, she founded the school in Glenside as her way of preserving Irish culture. The mother of five children, Rosemarie used her dancing as a way to instill confidence in the young. In 1997, she was grand marshal of the St. Patrick's Day Parade. She was one of 10 women honored in 2010 at the Irish Center with the inaugural Inspirational Irish Women Awards. (Keenan.)

The McDade Dancers posed for a group photograph in front of the Irish pub, Finnigan's Wake, in Northern Liberties. The front of the pub was designed to replicate the look of an Irish street with shopfronts. It has a large interior with the second floor celebrating the Irish 69th Brigade during the Civil War. The late Maureen McDade McGrory founded the McDade School of Irish Dance in 1962. Maureen began step dancing as a teenager. After Maureen's death in 1993, the school continued and is now the McDade-Carra School of Irish Dance.

In February 2009, the Irish American Business Chamber and Network, a nonprofit organization that promotes economic development and educational exchanges between the United States and Ireland, had a two-day event. There was a breakfast for His Excellency Michael Collins, Ireland's ambassador to the United States, at the Rosenbach Museum and Library, located at 2008–2010 Delancey Place. Derek Dreher, director of the Rosenbach, showed Ambassador Collins (right) a page from the manuscript of James Joyce's *Ulysses* (1922), foremost among the treasures of the museum. In 1924, Dr. A.S.W. Rosenbach, a rare book dealer, bought James Joyce's manuscript of *Ulysses*. To the left of Ambassador Collins were Christine Hartmann, President of the IABCN, and Brendan F. Boyle, Pennsylvania State Respresentative. (Keenan.)

At the Rosenbach Museum since 1991, notable Philadelphians have come together on Bloomsday, June 16, to commemorate the day in 1904 when James Joyce's *Ulysses* took place. John Timoney, Dublin-born former city police commissioner, was one of the readers at the ninth Bloomsday on June 16, 2000. Bloomsday is the only international holiday that recognizes one literary masterpiece with its fictional day when Leopold Bloom and Stephen Dedalus wondered through Dublin. (Keenan.)

At the ninth Bloomsday on June 16, 2000, Michael Toner, a talented Philadelphia actor and writer, read from *Ulysses* as he had done since 1991. Toner earned a master's degree in Anglo-Irish literature from University College Dublin, where he met many Irish playwrights and actors. A nationally known actor, Toner has had many one-man shows, which have included Samuel Beckett's *Beginning to End* and Brian Friel's *The Humours of Ballybeg*. (Keenan.)

On Friday, March 9, 2012, a solemn memorial service was held at West Laurel Hill Cemetery for the earthly remains of five Irish immigrants from Donegal, Tyrone, and Derry. Members of the Irish Brigade, the 69th Pennsylvania Irish Volunteers, stood guard during the public viewing of the five wooden caskets, including four men and one woman. They were among 57 laborers who died in August 1832, some from an outbreak of cholera and others as victims of violence. Their employer was Phillip Duffy, an Irish contractor, who had the lucrative contract for mile 59 of the railroad. They were buried in Duffy's Cut between Malvern and Frazier. (Keenan.)

The twin Watson brothers, Dr. William Watson (right) and Frank Watson (left), with their bagpipes in hand stood on either side of the Duffy's Cut memorial on March 9, 2012, as part of the reinterment ceremony. Dr. William Watson, a professor of history at Immaculata University, and his brother, Frank Watson, a Lutheran minister, worked with John Ahtes and Janet Monge from the University of Pennsylvania. After more than a decade's research, Dr. William Watson has pieced together much of the tragic story of the 57 Irish immigrants. (Keenan.)

Seven

THE LACE CURTAIN IRISH

The portrait of John B. Kelly Sr. (1889–1960) and Margaret Katherine Majer (1898–1990) was taken on their wedding day on January 30, 1924. They were married in St. Bridget Catholic Church in East Falls. Jack Kelly was one of 10 children of the immigrants Henry Kelly and Anne Costello of Mayo. He won three Olympic gold medals for rowing and became a self-made millionaire contractor. He ran for Democratic mayor in 1935, coming close to winning in a then heavily Republican city. (Temple University Urban Archives.)

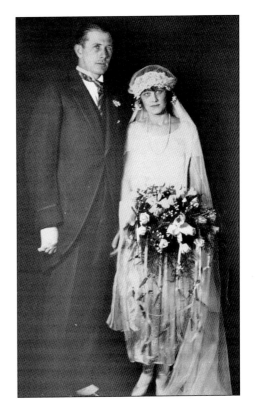

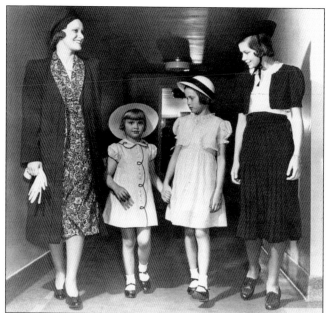

A former athletic coach and a fashion model for photographers, Margaret Katherine Kelly attended a bridge and fashion show with her three daughters, from left to right, "Lizanne" (4), Grace (8), and "Peggy" (12). It was held at the Penn Athletic Club in April 1938 to benefit the Woman's Club of Philadelphia's work with crippled children. Jack and Margaret Kelly had four children: Margaret Katherine (1925–1991), John Brendan Jr. (1927–1985), Grace Patricia (1929–1982), and Elizabeth Anne (1933–2009). (Temple University Urban Archives.)

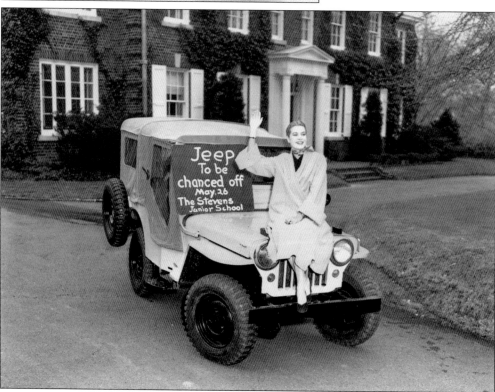

In April 1953, Grace Kelly, then a movie star with credits like *High Noon* and *Dial M for Murder*, posed on a jeep in front of her parents' 17-room East Falls home. The jeep was raffled at a fundraiser for her high school, the Stevens School in Germantown. Grace first attended the Ravenhill Convent Academy and then transferred in 1943 to the Stevens School graduating in May 1947. (Temple University Urban Archives.)

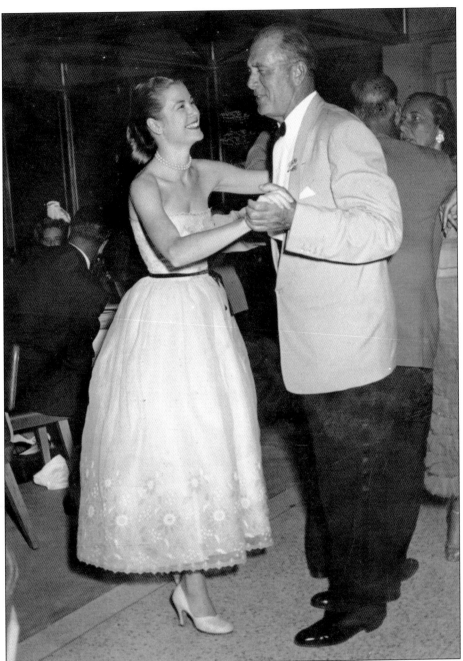

In 1946 at 17 years old, Grace danced with her handsome father, Jack Kelly Sr., at a family party. As a young girl, she was introverted and not athletic like her more energetic siblings. Her first theatrical role was in the play *Don't Feed the Animals* at the Old Academy Players in East Falls. It was Jack Kelly's brother George, himself a Pulitzer Prize–winning playwright, who encouraged his shy niece Grace to pursue her stage career. He helped her get admitted to the Academy of Dramatic Arts in Manhattan. Her legendary career included roles on television shows, such as *The Hallmark Hall of Fame*, the Broadway stage, and an Oscar-winning role in *The Country Girl* (1954). (Temple University Urban Archives.)

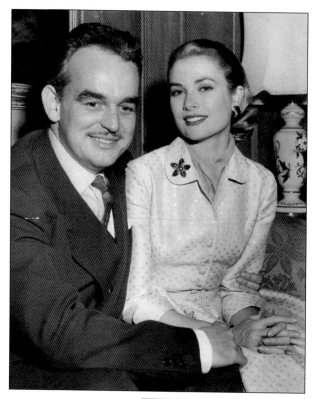

An engagement party on January 8, 1956, at her parents' home, Grace, the movie star, sat next to Rainer Louis Henry Bertrand Grimaldi, prince of Monaco, the world's most eligible bachelor. Their wedding was referred to as "the wedding of the century." There was a civil ceremony on April 18, 1956, with a religious ceremony the next day at Monaco's St. Nicholas Cathedral. Her Serene Highness Princess Grace of Monaco gave her wedding gown designed by MGM costume designer Helen Rose to the Philadelphia Museum of Art on June 4, 1956. (Temple University Urban Archives.)

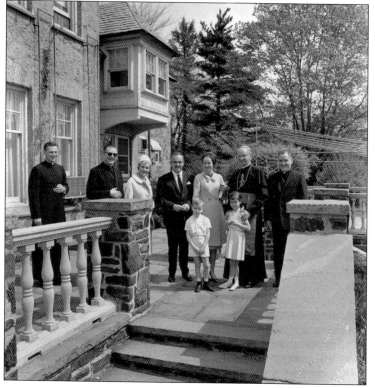

Her Serene Highness Princess Grace of Monaco and her husband, Prince Rainier III, their children, Caroline and Albert, along with Grace's mother, Margaret Kelly, visited Cardinal John Krol on April 22, 1963. After her marriage, she returned frequently to Philadelphia. Pictured are, from left to right, Rev. James F. Connelly, Bishop Francis J. Furey, Margaret Kelly, Prince Rainier, Princess Grace, Cardinal Krol, Bishop Gerald V. McDebitt, Princess Caroline, and Prince Albert. (PAHRC, Halvey)

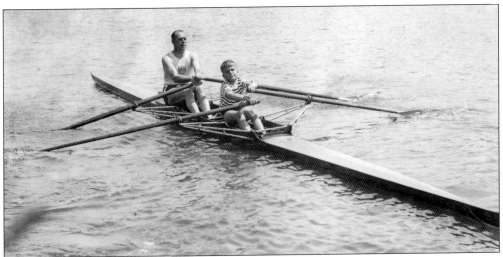

Jack Kelly Sr. and his seven-year-old son Jack Jr. were out for a practice row June 6, 1935, on the Schuylkill River. They were both Olympic medal winners in the Olympic Games for single scull and double scull. Jack Sr. won three gold medals in the 1920 and 1924 Olympic Games, and Jack Jr. won a bronze medal in the 1956 Olympic Games. Jack Jr.'s greatest triumph was his 1947 and 1949 wins at the Henley Royal Regatta in England, from which his father had been excluded in 1920 because he had worked as a bricklayer. (Temple University Urban Archives.)

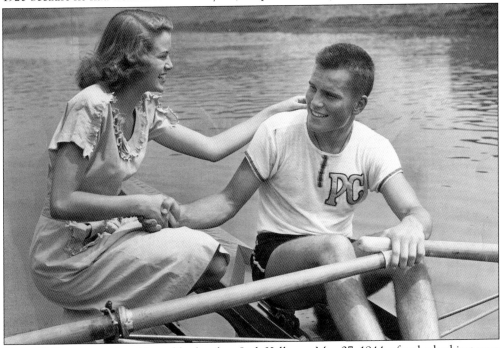

Grace Kelly congratulated her older brother, Jack Kelly, on May 27, 1944, after he had just won the singles scull race on the Schuylkill River for his high school team Penn Charter, a Quaker preparatory school. In 1946, Jack went onto study at the University of Pennsylvania, where he was a varsity rower and participated in the 1948 Olympic Games. He worked for the US Olympic Committee and became its president in 1985 shortly before his sudden death at age 57 on March 2, 1985, from a heart attack. (Temple University Urban Archives.)

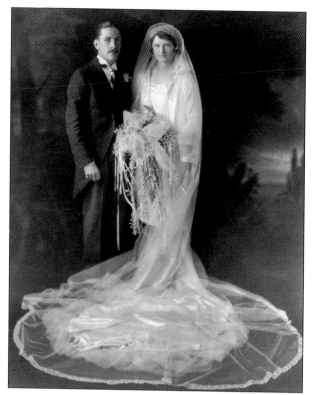

On May 28, 1927, John McShain, a 28-year-old first-generation son of a well-to-do Irish builder of Catholic church buildings, married Mary Butler Horstmann, daughter of wealthy Ignatius Horstmann, owner of the I.J. Horstmann & Sons wool-processing business. The wedding took place at St. James' Catholic Church with a bishop officiating and 30 priests present. In October 1934, Mary's mother, Pauline Horstmann, died, and the new McShain family moved into Ignatius Hortsmann's home in Overbrook with their daughter. (Hagley Museum.)

John McShain (1898–1989) was one of America's greatest builders. His father, John McShane Sr. (1860–1919), born in Slaughtmanus, Derry, founded his own contracting firm in Philadelphia in 1888. McShane Sr. built many local catholic buildings. McShain Jr. developed John McShain, Inc., which became one of the five largest construction firms in the United States. McShain got major federal government contracts for a period of over 30 years, including the construction of the Pentagon from 1941 to 1942 and the rebuilding of the White House from 1949 to 1952. (McShain.)

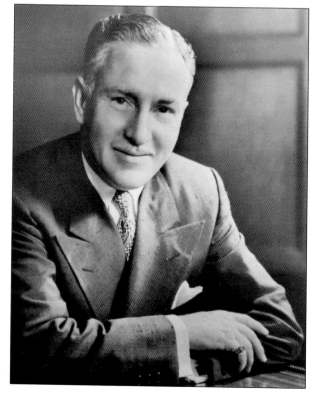

John McShain posed with his racehorse Ballymoss, which had just won the Irish Derby at the Curragh in 1957. Horse racing got McShain away from the pressures of his construction business. He operated Barclay Stables in New Jersey. Vincent O'Brien, a legendary Irish horse trainer, trained Ballymoss at his stables in Ballydole, Tipperary. Ballymoss won eight races including the 1958 King George VI and Queen Elizabeth Stakes at Ascot. (Hagley Museum.)

In 1968, 70-year-old John McShain drove his daughter, Sr. Pauline McShain, SHCJ, and his wife, Mary, in a horse-drawn jaunting trap through the Gap of Dunloe, County Kerry. The McShains acquired Killarney House in 1960 along with 25,000 acres. In 1973, the McShains gave most of land to the Irish State. John and Mary spent their last years at Killarney House. When Mary died in 1998, the entire estate became part of the Killarney National Park. (Hagley Museum.)

On February 21, 1900, at St. Philip Neri Church, Joseph Charles Trainer (1872–1943) married Wilhelmina "Minnie" Wurster, his childhood sweetheart. Joseph C. Trainer was the fourth child of Edward Trainer, who had established a successful wholesale liquor business called Edward Trainer Wines & Liquors in South Philadelphia. Edward Trainer (1841–1914) had made a small fortune on his Old Reserve Blended Whiskey sold in a dark-green bottle, made by Hamilton Glass. Joseph C. Trainer worked in the family business selling whiskey to many of the 5,500 saloons in the city, and his extended family sold this popular whiskey in their saloons. (Trainer.)

In 1900, Joseph and Minnie Trainer moved into their home at 1513 South Broad Street, a gift of Edward Trainer to the newlyweds. Minnie gave birth to seven boys, and their son, Francis H. Trainer, wrote a memoir *Daring Greatly: A History of the Trainer Family*, which outlined an idyllic childhood. Joseph Trainer's business and political careers flourished. He was elected state senator in 1930 and ran on the platform of repealing the Prohibition Amendment. In 1925, he served as chairman of the St. Joseph's College Foundation Committee and gave $100,000 for the building of the college's Barbelin Hall. (Trainer.)

Joseph C. Trainer died at Cranaleith on February 10, 1943. On October 4, 1944, the six brothers and their wives posed for this photograph on the front lawn of Cranaleith, which stayed in the family. Pictured are, from left to right, Edward and Dot, Francis and Mary, Joe and Kay, Ray and Ann, Bob and Adele, and Clem and Peg. In 1949, Joseph's son Francis H. Trainer (1907–1997) moved his own family of four children into his boyhood summer home. (Trainer.)

AINER'S LAKE AND MANSION SOMERTON PA. —PHOTO BY M.H.5LIX

On April 28, 1906, Joseph C. Trainer purchased a large summer home in what was then rural Somerton so his children would have a place in the country. Rachel Foster Avery, a suffragette and close friend of Susan B. Anthony, built the home in 1891. The house was named Cranaleith, a combination of the Irish birth towns in County Tyrone of his mother, Cranlome, and his father, Arvalee. In 1916, Joseph Trainer purchased the adjoining properties so that in time Cranaleith stood on 100 acres. Joseph transformed a pond fed by a local stream into what became known as Trainer Lake. In 1996, Francis Trainer in partnership with the Sisters of Mercy created a not-for-profit foundation, the Cranaleith Spiritual Center. (Trainer.)

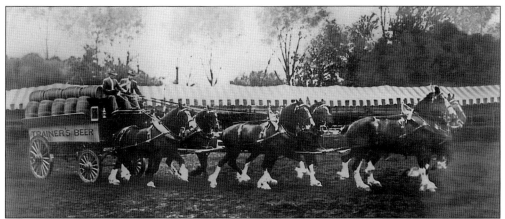

After the repeal of the 18th Amendment, which ended Prohibition in 1933, the Trainer's beer wagon, pulled by six Clydesdale horses, promoted the Trainer Brewing Company. Prohibition, which became a law on January 16, 1920, was a great blow to the Trainer family. Luckily, the family had diversified into other businesses. In 1912, Joseph C. Trainer had purchased the Premier Brewery and had started the Colonial Ice Cream Company in 1919. Joseph C. Trainer's most successful purchase was his 1927 purchase of the Roller Bearing Company of America, located in Trenton, New Jersey. (Trainer.)

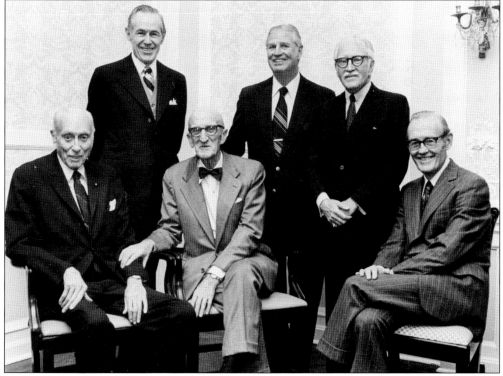

On March 1, 1977, the Catholic Philopatrian Society gave a dinner in special recognition for the "Super Philos," who donated and raised millions for the benefit of local Catholic institutions. Honored that night are, from left to right, Leo Manz, Clement Trainer, Ignatius Horstmann, Albert Tegler (representing the Philo Society), John McShain, and Raymond Trainer. This group helped form the Catholic Charities Corporation in 1955 to consolidate archdiocesan charity work. (PAHRC, Halvey)

Henry P. McIlhenny (1910–1986) sat for his portrait in the drawing room of his castle, Glenveagh, located in County Donegal. His paternal grandfather, John McIlhenny, born near Glenveagh, left Ireland in 1843 and settled in Columbia, Georgia, from Philadelphia. John McIlhenny invented the gas meter and established the lucrative firm Helme and McIlhenny, which produced these meters. Henry McIlhenny's own father, John Dexter McIlhenny, continued to grow the family fortune, which enabled Henry to live a gracious life dedicated to art. (Temple University Urban Archives.)

In 1938, Henry McIlhenny purchased Glenveagh, a 19th-century 23-bedroom castle situated on 25,000 acres of land. Over the years, he entertained lavishly in his castle. In 1974, he sold most of his land to the Republic of Ireland for the creation of a national park. In 1979, he gave Glenveagh Castle as well as an additional 15 acres to the Republic of Ireland retaining the right to live there until his death. While in Philadelphia, he lived at 1914 Rittenhouse Square. His art collection became the Philadelphia Museum of Art's McIlhenny Collection. (Temple University Urban Archives.)

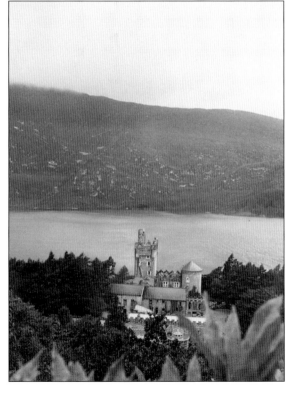

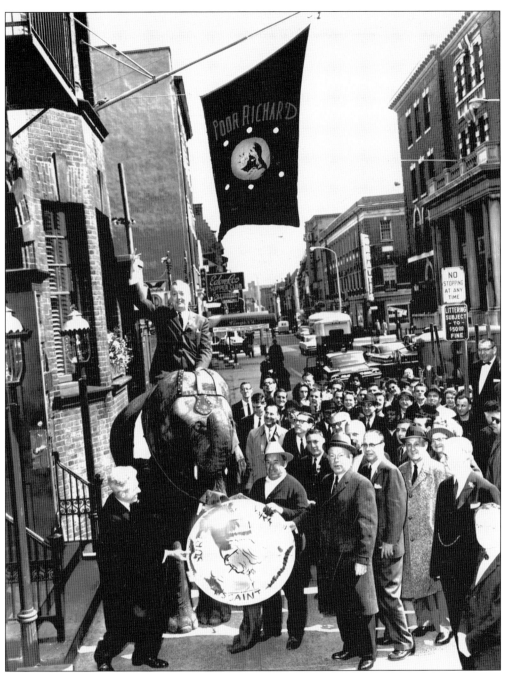

Patrick Stanton (1907–1976), born in County Cork, was Philadelphia's best-known Irish radio broadcaster and producer of the popular *Irish Hour*. The theatrically bent Patrick Stanton sat on an elephant behind the banner "Sure and Begorrah Its Saint Benjamin" in front of the Poor Richard's Club at 1319 Locust Street, which held a testimonial dinner in 1968 for Stanton. Stanton promoted Irish culture throughout his career. Stanton sold shamrocks annually around St. Patrick's Day to benefit the Ballaghaderreen Orphanage in Ireland. (Historical Society of Pennsylvania.)

Patrick Stanton produced and narrated *Here Is Ireland* in 1939, which had its local premier at West Philadelphia's Belmont Movie Theater at Fifty-second and Filbert Streets. It was produced by the Irish American Film Corporation and was the first full-color feature travelogue about Ireland. The film was one of three Irish travel films he made and featured Stanton's lifelong friend Éamon de Valera, the prime minister and president of Ireland. He served as Mayor James Tate's press secretary. (Historical Society of Pennsylvania.)

Matthew H. McClosky (1893–1973) was born in Wheeling, West Virginia, and was a powerful Philadelphia contractor and treasurer of the Democratic party. He donated, and Cardinal Krol accepted $500,000 to endow the Archdiocesan Educational Fund, benefitting Catholic high schools. He had been a heavy voice in the Democratic party, along with John B. Kelly Jr., and was also Philadelphia city Democratic chairman since the 1940s. John Kennedy made him US ambassador to Ireland during his administration. (PAHRC)

John F. Connelly (1905–1990), on the right, received the Fr. Edward Sourin Award from Albert W. Tegler on May 25, 1977, at the annual banquet held at the Barclay Hotel. The Sourin Award was named after the founder of the Catholic Philopatrian society, Fr. Edward Sourin, SJ. In 1946, Connelly founded Connelly Container Corporation and later purchased the ailing Crown Cork and Seal Corp. His Connelly Foundation has given away over $74 million to local Catholic charities. (PAHRC, Halvey)

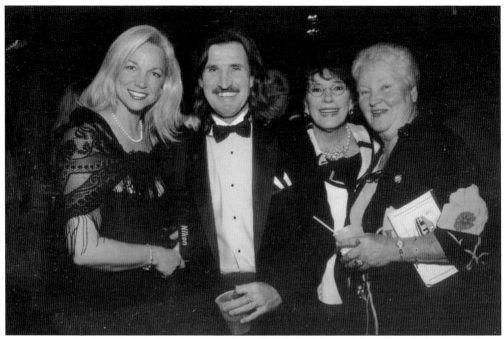

On November 17, 2006, the Delaware Valley Irish Hall of Fame inducted Patricia Noone Bonner (right) at their annual gala at the Irish Center. She is seen with her daughter Marybeth Bonner Ryan (left), photographer for the *Irish Edition* Tom Keenan (center), and Delaware Valley Irish Hall of Fame Board member Kathy McGee Burns (second from right). Patricia Noone Bonner has dedicated her life to the cause of a United Ireland. (Keenan.)

Seamus P. McCaffery was born June 3, 1950, in Belfast, Northern Ireland. After active duty in the Marine Corps, McCaffery joined the Philadelphia Police Department. At night, he earned his bachelor's degree from LaSalle University as well as a law degree in 1989 from Temple University's Beasley School of Law. McCaffery, along with city councilman Jim Kenney, founded the Eagles Court, a night court that administered speedy justice to unruly fans. He was elected justice of the Superior Court of Pennsylvania in 2004 and justice of the Supreme Court of Pennsylvania in 2008. (*Philadelphia Inquirer.*)

Eight

THE WEARIN' OF THE GREEN

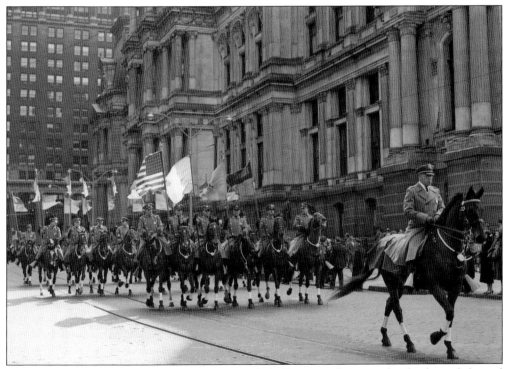

The weather-delayed 1954 St. Patrick's Day Parade held on March 21 was the third parade hosted by the newly formed St. Patrick's Day Observance Association. The Philadelphia Mounted Police, shown as they moved around city hall, led the 20,000 marchers. The St. Patrick's Day Observance Association brought the parade back in 1952 after a 20-year hiatus. The parade has been a great day for the Irish in Philadelphia. (PAHRC, Halvey)

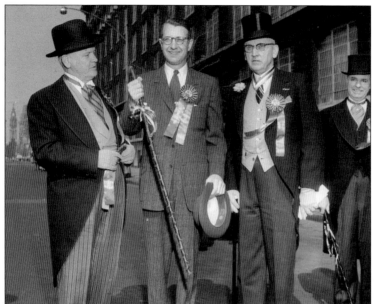

The 1957 St. Patrick's Day Parade had Gov. George M. Leader as its guest of honor, who proudly carried his blackthorn shillelagh. To the left was Sheriff William M. Lennox, president of the St. Patrick's Day Observance Association. To the right was Judge Vincent A. Carroll, parade marshal. Lennox and Carroll were a part of the executive committee that brought the parade back in 1952. (PAHRC, Halvey)

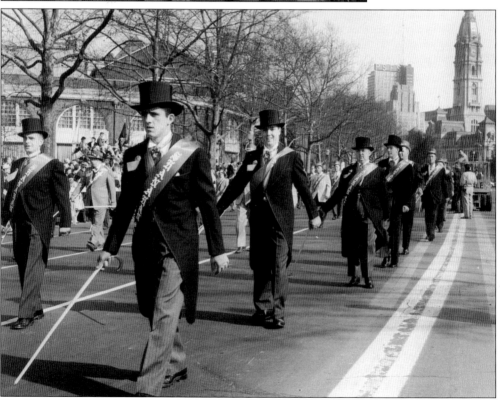

The Shanahan Catholic Club of West Philadelphia wore matching morning coat cutaways with tails complete with topper hats and Kelly-green sashes. The Shanahan Catholic Club had a large clubhouse at 4600 Lancaster Avenue with eight bowling alleys and a swimming pool. Rev. John W. Shanahan, pastor of Our Mother of Sorrows Church, founded the club in 1895. Sixth in line is current parade director Michael Bradley's father, Mickey.

Cardinal Dougherty High School's drill team led the school's marching band in the 1961 parade. Cardinal Dougherty High School, built in 1956, was named after Cardinal Dennis Joseph Dougherty, archbishop of the Philadelphia Diocese from 1918 to 1951. The band won a world competition in the Netherlands in 1966. (PAHRC, Halvey)

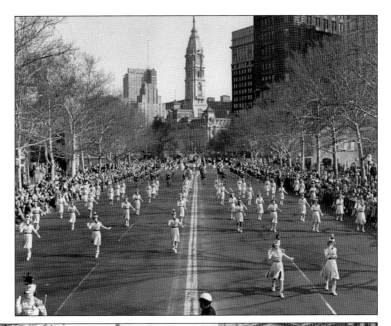

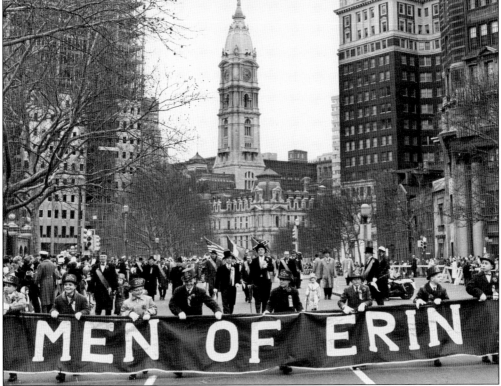

In the 1962 parade, the "Men of Erin," also known as "Quinn's Men of Erin," carried their controversial banner. The banner could not say Quinn's since parade rules did not allow business promotions. Charles Quinn was an affable tavern-keeper from Swampoddle. Mayor James H.J. Tate, the tall man in the center, marched the route twice, first to lead the parade and then to march with the Men of Erin. (PAHRC, Halvey)

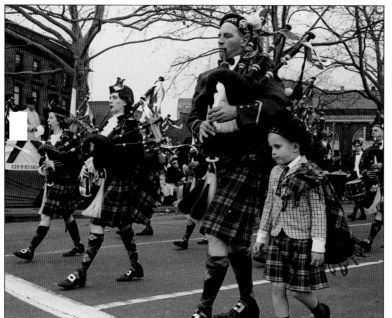

In 1964, the Clan na Gael pipe band members wore their Highland tartan kilts, checkered bonnets, fitted doublets, dress shirts, and sporrans. Bagpipers have been associated with the Irish in the city's fire and police departments. The great Highland bagpipe came over with the colonist Irish who played the bagpipe at funerals, weddings, and gatherings. (PAHRC, Halvey)

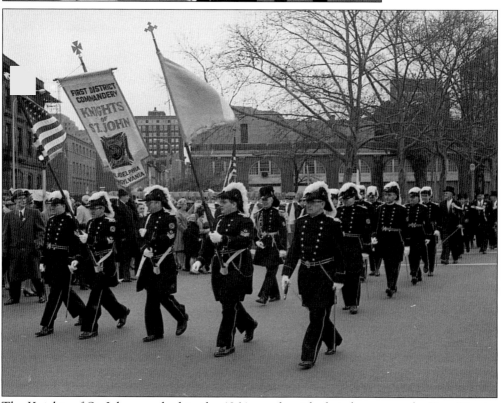

The Knights of St. John marched in the 1964 parade with their banner as the First District Commandery. The society, formed in 1879, was called at first the Roman Catholic Union of the Knights of St. John. In Philadelphia, they worked with local parishes to promote the Catholic religion and create fellowship among its membership. (PAHRC, Halvey)

Members of the Philadelphia Irish Musicians Union, Local No. 17, marched in the 1964 parade playing Irish popular music on banjo, fiddle, and accordion. They dressed in jaunty bowler hats with spats like Irish gangsters. (PAHRC, Halvey)

The 1967 parade was the first year that Mayor James J. Tate was grand marshal. He served as the grand marshal every year until 1978. James Hugh Joseph Tate (1910–1983) served as the first Catholic mayor of Philadelphia between 1962 and 1972. Over 200,000 spectators watched the parade that year with nearly 20,000 participants. (PAHRC, Halvey)

In the 1967 parade, the Ancient Order of the Hibernians, Division, No. 2 Board of Erin, marched with their distinctive sashes. To be a member of the Ancient Order of the Hibernians in America, the member must be a Catholic and either Irish born or of Irish descent. (PAHRC, Halvey)

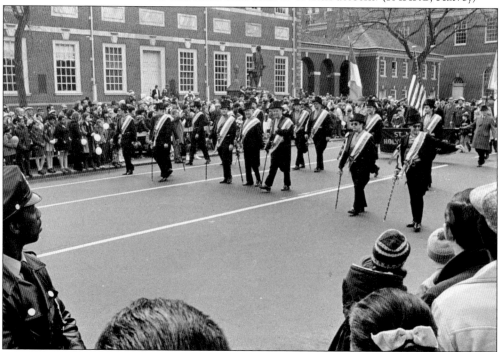

The officials marched in the 1975 parade on the new route that ended in front of Independence Hall. Approaching America's bicentennial year of 1976, officials thought this route would highlight Irish patriotism. The officials included Patrick Brown, president of the St. Patrick's Day Observance Committee; Thomas Gibson, parade director; and Hon. James Tate, grand marshal. (PAHRC)

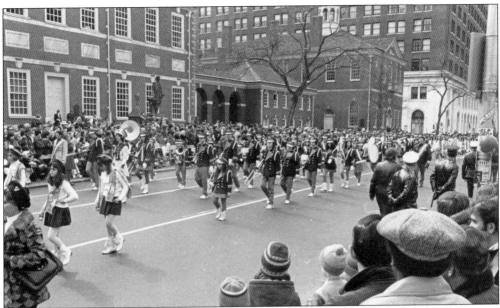

The marching band of St. Martin of Tours School passed in front of Independence Hall in the 1975 parade. This parish church and school opened in 1928 when many Irish moved from densely populated urban areas to newly constructed homes in Northeast Philadelphia. (PAHRC, Halvey)

During the bicentennial year, the City of Philadelphia had transitioned to Italian American mayor Frank Rizzo, former police commissioner. He waved to the assembled crowd. His 1980 Democratic mayoral successor, the handsome Irishman William J. Green III, stood two men to the right. William Green's father, Bill Green, was among the most powerful Democratic members of the US House. After one term as mayor, Green established himself as a lobbyist in Washington, DC. (PAHRC)

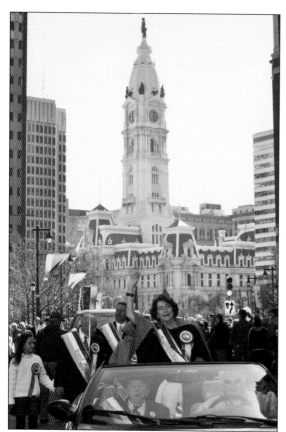

Kathy McGee Burns, the 2012 president of the St. Patrick's Day Observance Committee, rode along the parade. Since 2009, cash-strapped city officials have charged the committee a hefty fee to provide sanitization and police protection. Undaunted by this, parade director Michael Bradley rallied the other ethnic parade leaders and spearheaded the effort to raise the funds, shortened the parade, and returned the reviewing stand to the Benjamin Franklin Parkway. (Keenan.)

Four of the five children of Esther and Peter Finnegan gathered for the wedding reception of Catherine Finnegan in 1945. Margaret Mary Finnegan Krivda (third row, second from left) gave the reception at her new home in Oak Lane. The two women with the corsages were her only sister, Catherine, and her mother. The Finnegan family's intelligence, ambition, and love for Ireland have inspired the author. (Krivda.)

INDEX

DISCOVER THOUSANDS OF LOCAL HISTORY BOOKS FEATURING MILLIONS OF VINTAGE IMAGES

Arcadia Publishing, the leading local history publisher in the United States, is committed to making history accessible and meaningful through publishing books that celebrate and preserve the heritage of America's people and places.

Find more books like this at
www.arcadiapublishing.com

Search for your hometown history, your old stomping grounds, and even your favorite sports team.